AND THE
CANARY

Drawing
& Painting
CATS

Vic Bearcroft

SEARCH PRESS

First published in 2016
Search Press Limited
Wellwood, North Farm Road,
Tunbridge Wells, Kent TN2 3DR

Text copyright © Vic Bearcroft 2016
Photographs by Paul Bricknell
Copyright © Search Press Ltd 2016

Additional photographs by Paul Bricknell at
Search Press studios.
Design © Search Press Ltd 2016

ISBN: 978-1-78221-112-9

The Publishers and author can accept no responsibility
for any consequences arising from the information,
advice or instructions given in this publication.

Readers are permitted to reproduce any of the
drawings and paintngs in this book for their personal
use, or for the purposes of selling for charity, free
of charge and without the prior permission of the
Publishers. Any use of the drawings and paintngs for
commercial purposes is not permitted without the prior
permission of the Publishers.

Suppliers

For details of suppliers, please visit the Search Press
website: www.searchpress.com.

Publisher's note

All the step-by-step photographs in this book feature
the author, Vic Bearcroft, demonstrating how to draw
and paint cats. No models have been used.

Printed in China

Acknowledgments

Roz Dace, for believing in me from the start;
Edd Ralph, my editor for the second time, who always
seems to be on my wavelength; Katie French, for
allowing myself and Edd so much creative freedom
for this project; Juan Hayward and the design team for
putting it all together visually; and Paul Bricknell, a great
photographer and fun to be with in the studio sessions.

Huge thanks to The Wildlife Heritage Foundation in
Kent, UK for first inspiring me to paint big cats with their
many and varied feline tenants; and for their tireless
conservation work for endangered cat species.

Finally, thanks and treats go to my 'moggie models' –
scientific names in brackets. Ned (Neddy Pikey),
Nell (Nellbert), Marley (Marley Bucket), Forrest
(Fozzie Bear), Gladys (Gladders Growbag),
Oscar Wildecat (Nobbles), Phoebe (HRH Naughty
Knickers), Leon (Leon Cullen Arizona Shadow),
Skunk (Skunky Monkey), Squirrel (Squirrel Nutkin),
Twilight (Twiglet), Nina (Neeneen Pauline) and
Roo (Ruby Roo).

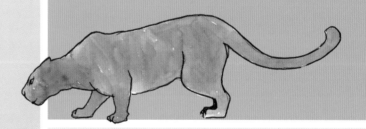

Page 1

Black Velvet

*Black velour is a great surface for painting black cats in pastel. As you do
not need to paint the mass of dark fur, you can enjoy spending your time on
building the highlights.*

Pages 2–3

Cat Tails

*Sepia ink pen and sepia ink washes on watercolour paper gives an old-
fashioned book feel to this painting of my cats Ned and Marley enjoying
some of my favourite books.*

Opposite

Kit-Ten-Katmun

*Ink pen on brown kraft paper helps to create the dark tomb-like atmosphere
in this light-hearted drawing depicting the significance of cats in ancient
Egyptian culture.*

Contents

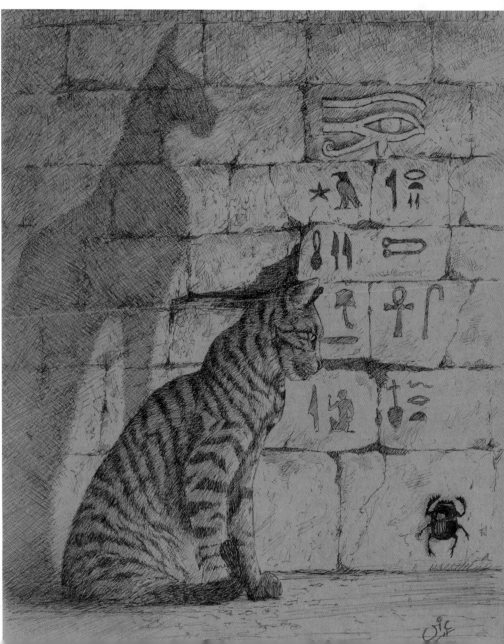

Introduction

Throughout our lives we are surrounded by images of cats of all types, and many of us are fortunate to be able to have smaller versions of the big cats we see in zoos, movies and television in our own homes. Much has already been written about cats (family *felidae*) and the many varieties within the family. As an artist, I will not attempt to expand upon that wealth of scientific writing. Instead I will focus on the popular distinction between domestic cats and so-called big cats. Although not zoologically correct, the term 'big cats' will be used to refer to all the larger wild cats of the type that may be seen in zoos and wildlife sanctuaries.

The combination of grace and power that all cats possess, whether big or small, is highly attractive. It is unsurprising, therefore, that cats have been celebrated throughout recorded history in fiction, poetry and fine art. Their pleasing appearance aside, part of their appeal for artists is undoubtedly their independence, which means that, no matter how much we believe we can tame them, they are just a whisker away from wildness.

Domestic cats have a reputation for being independent-minded purrsonalities, who have more control over their humans than the other way around. At the time of writing this book, I am being held hostage by twelve cats; this is likely to have changed by the time the book is published and in your hands.

Most of us, quite rightly, do not keep big cats as pets in our homes, but we can learn a lot about one type from the other and vice versa. Whether you are owned by felines or simply enjoy painting them, I hope you will find this book instructive and entertaining.

Nell
Pastel on velour. Close cropping can really focus on and enhance the beautiful eyes of a cat, like those of my cream tabby, Nell, shown here.

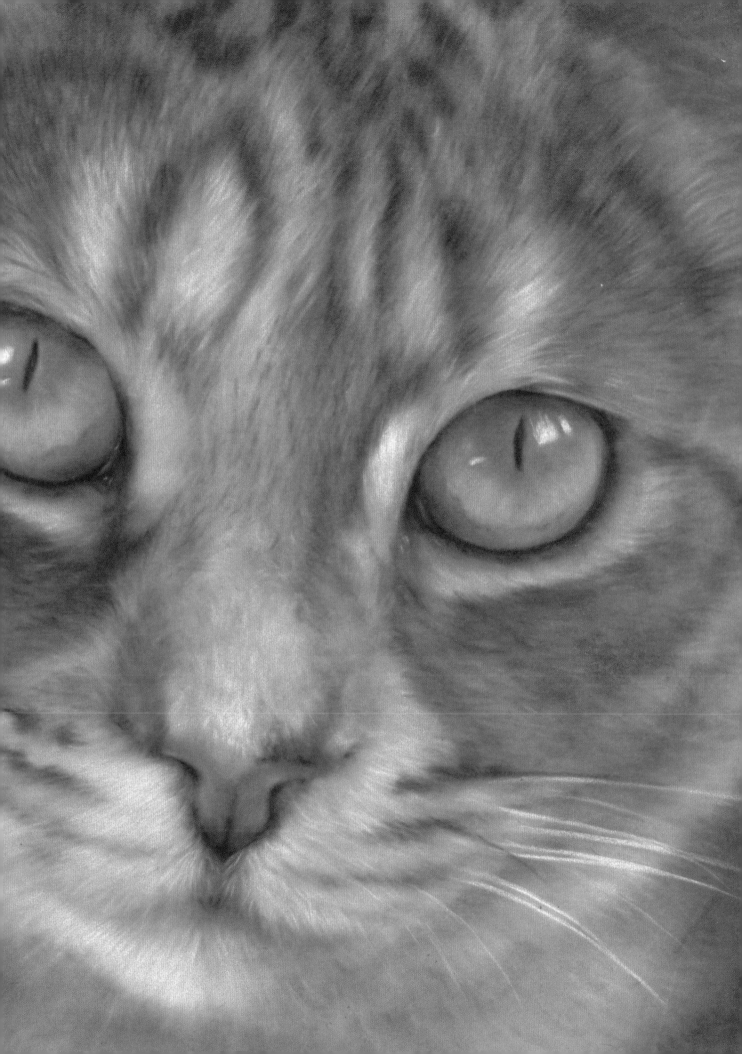

Cats in art through history

Appearing in art from prehistoric cave paintings to modern pop culture, cats have captured the imagination of people across the world. It is widely accepted that wild cats were first domesticated about ten thousand years ago, in what we now know as Egypt, and worshipped as cult icons by the ancient Egyptians. There were even goddesses in human form with cat or lioness heads.

Many artists share with cats an independent streak. Many very famous artists also owned cats which became studio companions and muses: artists such as Henri Matisse, who owned cats called Minouche and Coussi; Pablo Picasso and Minou; Gustav Klimt and Katze; and Salvador Dali with his pet ocelot, Babou. It is unsurprising that as well as having cats as companions, many artists use them as models in their artworks.

Some of these artworks have become rightly famous. The French post-impressionist artist Henri Rousseau famously produced a series of naïve jungle paintings featuring lions and tigers, among other creatures, which became his most well-known and popular works. Perhaps the best-known feline image in contemporary art is the black cat featured in posters advertising the Paris nightclub *Le Chat Noir* in the late 1800s, an image reproduced in many different forms to the present day.

Smilodon

Smilodons, popularly known as sabre-tooth tigers, are an extinct species of cat popularised in recent years by the Ice Age *series of animated films. They appeared in cave art alongside other large and powerful prehistoric cats such as cave lions.*

Sekhmet

Ink pen and coloured pencil. Sekhmet was a lioness-headed warrior goddess to the ancient Egyptians, who worshipped a number of other cat and cat-headed deities like Bastet.

Henri's Cat

Acrylics on hot-pressed watercolour paper. This is my homage to Henri Rousseau who, like myself, loved to paint animals in dense, dark jungle habitats.

Paws For Thought

Andy Warhol once owned twenty-five cats, all named Sam!

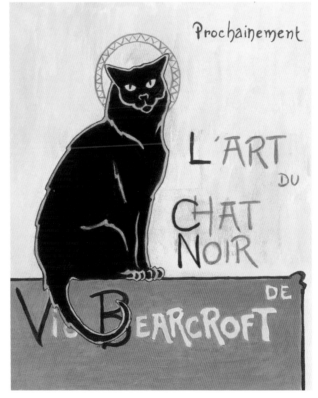

Le Chat Noir

Painted using acrylics, this is my homage to Théophile Steinlen's iconic original nightclub advert, the full title of which is La Tournée du Chat Noir avec Rodolphe Salis. The model used here is my own 'Chat Noir' – Squirrel.

Cats in fiction and popular culture

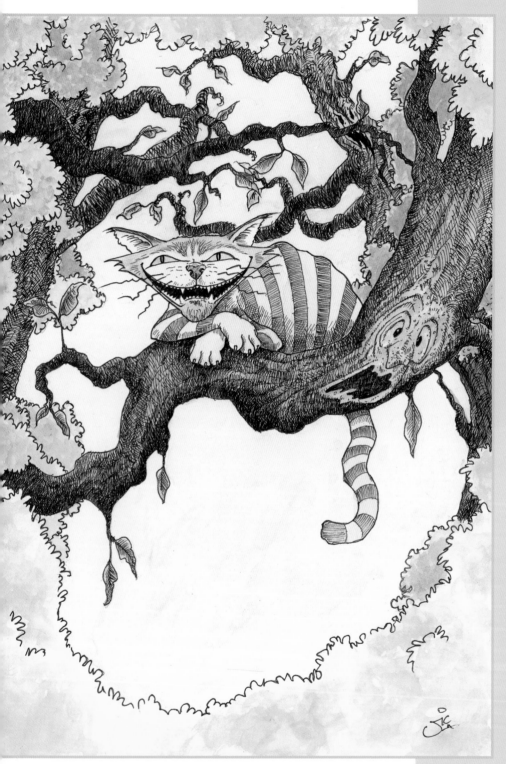

From man-eating tigers to regal lions, cats of all types have been widely portrayed in fiction and popular culture. Witches were once thought to keep black cats as familiars, and the fluffy white house cats of sinister supervillains are a common image. Cats have appeared both as evil protagonists and as heroic helpers in folklore.

Most of us, I am sure, have fond memories of fictional feline characters such as Dick Whittington's Puss-in-Boots; the Cheshire cat from *Alice's Adventures in Wonderland* by Lewis Carroll; Shere Khan and Bagheera from Rudyard Kipling's *The Jungle Book* and its sequel; not forgetting of course T S Eliot's volume of poetry *Old Possum's Book of Practical Cats* on which the very popular musical *Cats* was based.

Cartoon cats in particular are almost too numerous to mention; Tom from *Tom and Jerry* being arguably the most famous, alongside others such as Garfield, Top Cat, Tigger, Simba from Disney's *The Lion King* and the once very popular Pink Panther.

Let's not forget the power of felines in advertising, either. From *Le Chat Noir* (see pages 8–9) to the present day, cats of all shapes and sizes have found themselves promoting everything from breakfast cereals to petrol.

Cats have always taken, and will continue to take, centre stage in popular culture, continuing to provide inspiration for artists like myself – and you.

We're All Mad Here

Ink pen and watercolour were used for this rendition of Lewis Carroll's Cheshire cat, played here by Forrest, my ginger cat.

Opposite:

Oh My!

The cowardly lion from The Wizard of Oz makes a great subject for this ink pen and watercolour piece. How many faces can you find in the trees of the haunted forest?

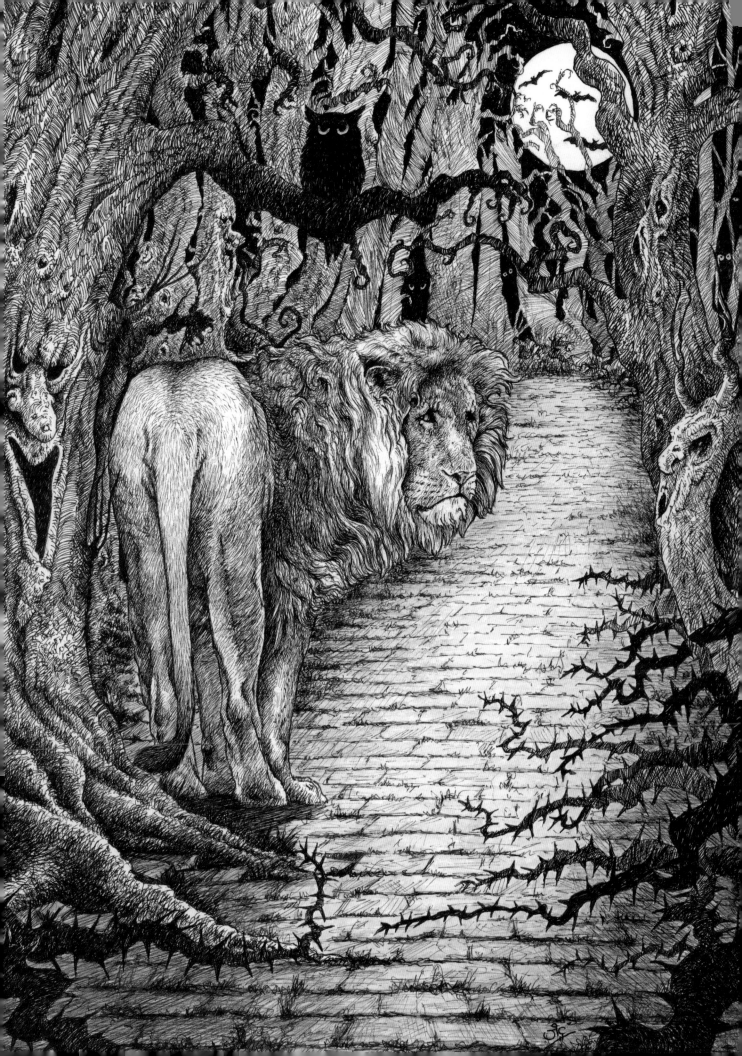

Initial
sketching

A graphite pencil is probably the easiest
and most popular tool with which to begin
sketching. The fact that it is softer in tone
than an ink pen not quite as messy as
charcoal and can be erased if required,
makes graphite a less daunting prospect for
those new to sketching.

Various techniques can be used with a
graphite pencil, from delicate hatching with
harder pencils to quite dark tonal shading
with the softer ones. The following pages will
ease you into drawing cats by working from
quick sketches into full drawings.

Materials for sketching

The materials described here are the most basic tools of any cat artist. They are important, and will be used not just in this chapter, but throughout the rest of the book.

Pencils Graphite pencils are graded along a scale of 'H' for hardness and 'B' for blackness (softness). A standard HB sits in the middle of the range. If it has a number ranging from 1–9, this indicates the relative hardness or softness of the pencil, with the very hardest being 9H, for example. For most of my graphite sketches, I use a 2B pencil. This is soft enough for subtle midtone shading but hard enough to retain a sharp point for finer details. Coloured and white pencils make an interesting alternative to graphite pencils for sketches on black or tinted paper.

Paper surface A hardback spiral bound sketchbook with 150gsm (100lb) cartridge paper is ideal for pencil sketching as it can be used anywhere, from the sofa at home to an enclosure at the zoo. It also has a slightly textured surface that holds graphite well without too much smudging. Brown and black papers are great surfaces for coloured or white pencil sketching.

Pencil sharpener I use a double sharpener, firstly to shape the wood and expose more of the lead; secondly to create a sharp point. The sharpener is enclosed to catch messy shavings.

Dust-free eraser This type of eraser produces far smaller amounts of eraser dust than a regular plastic eraser. Dust-free erasers are also smudge-free, which helps to give a nice clean finish to your pencil work. Erasers can be used as a tool for 'cutting out' highlights.

Paws for thought
Cartridge paper is so-called because it was originally used on the casings for shotgun cartridges.

Cat anatomy

Drawing cats benefits from an understanding of the basic shapes that make up the form of the cat. Generally, there is not much difference between the anatomical form of big cats and domestic cats, and they share many similar features. Naturally, there will be slight variations in leg length, skull size, eyes, teeth and so on, but essentially, both are 'built' more or less the same way, for similar reasons.

All cats' bodies, whatever their size, are built primarily for hunting. This means that their hind legs are very strong to enable them to spring forward and jump to catch prey – whether this is a zebra on the Masai Mara, or a clockwork mouse in your own living room. The almost primaeval predatory stare of a tiger is often evoked in the familiar eyes of our own house cats. Nevertheless, there are some important differences between big cats and domestic cats for the artist to consider, which will be covered over the following pages.

Opposite

The Mousetrap

I sometimes wonder what it would be like to have a young tiger in the house. How might it interact with cat toys? I suspect he would need a very big litter tray!

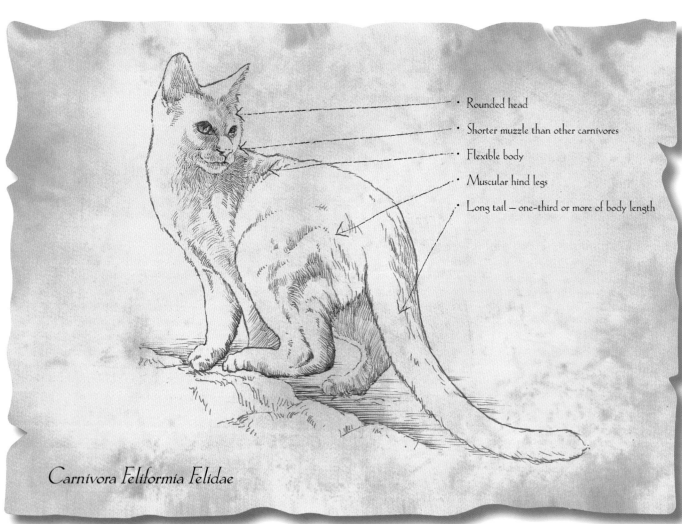

- Rounded head
- Shorter muzzle than other carnivores
- Flexible body
- Muscular hind legs
- Long tail – one-third or more of body length

Carnivora Feliformia Felidae

The Form of the Cat

In the style of an old Albrecht Dürer animal drawing, this image summarises some of the most distinctive features common to cats of all types.

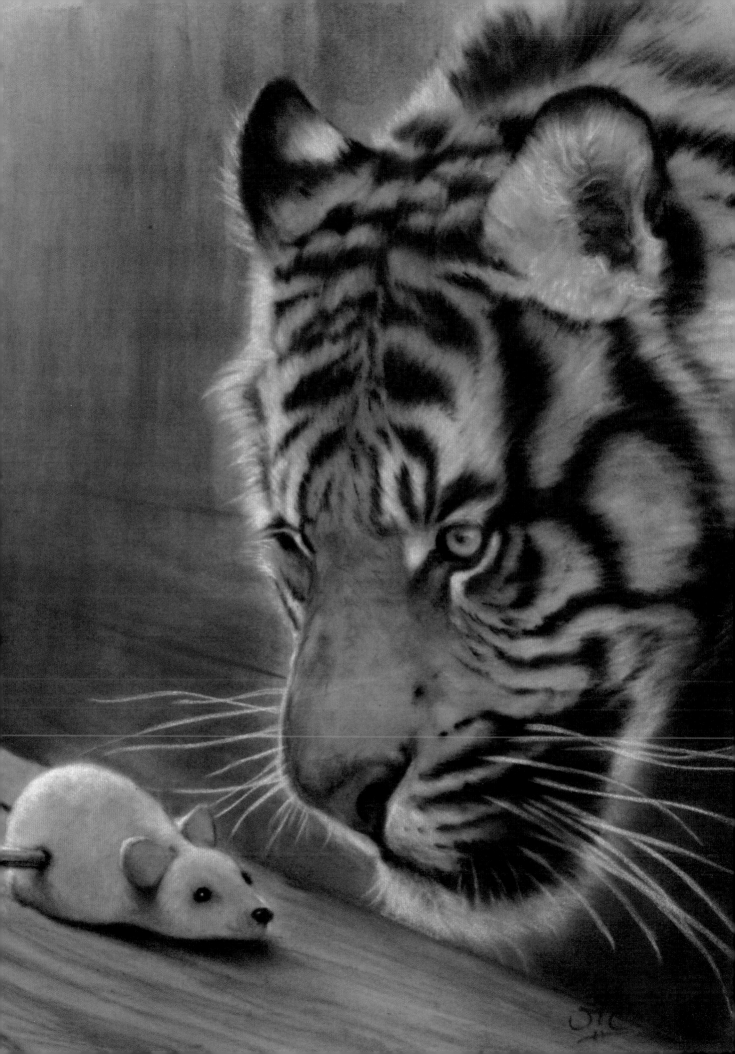

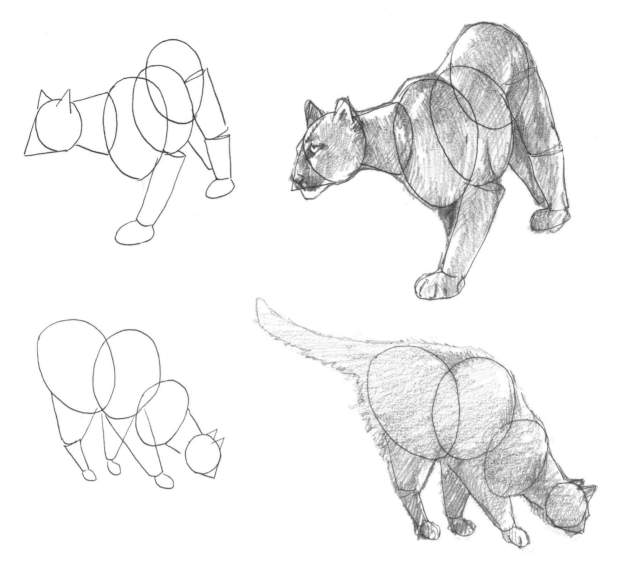

Examples of underlying basic body shapes

Basic shapes

Whatever your subject, simplifying an object by breaking it down into common geometric shapes is a good starting point for understanding the proportions and way that it is put together – how large the head is compared with the body, for example, or what size and shape the ears are, and so on. This applies to cats just as much as it does to people, objects or even landscapes.

Drawing cat body shapes

Most of my paintings, drawings and illustrations start with the use of a 2B pencil to make simple shapes and angles in my sketch book. Circles, triangles and ovals of differing sizes can be used to piece together your feline puzzle – for example, ovals to represent the hip/thigh area, ribcage, shoulder/chest area and a circle for the head. I usually begin with the head as a circle, particularly if I am intending to sketch most or all of the body. This is because getting the head placed correctly will help you to assess the space you need to position the rest of your cat correctly – and fit it on the page.

The cat's powerful hind legs generally give a kind of egg-shaped body, thicker and rounder at the back, tapering more towards the head end. Attaching an oval to represent the ribcage to the head circle will begin the basic feline body shape.

The spine line

All cats have very flexible spines, allowing for great variety of movement – twisting, turning and jumping. As a result, the line created by the spine – which runs from the head to the tip of the tail – can help not only to unify the basic body shapes, but also to create dynamic poses.

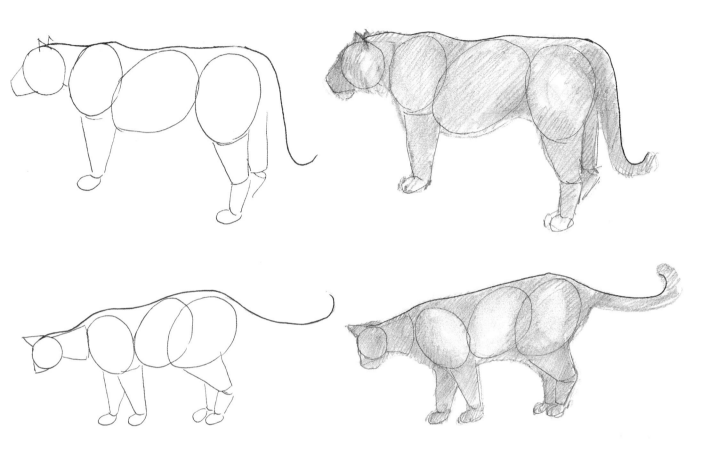

Examples of underlying body shapes with the spine line established

The spine line and sketching

Getting the spine line correct from the first pencil strokes gives you an excellent reference point from which to build up the other basic shapes. Familiarity with the idea and practice through your initial sketching will feed through to both your preparatory sketches and finished artworks.

Cartoons

Our early childhood experiences of animals might be with household pets, but also cartoon animals in films, on television or in comics. I used to love drawing cartoons as a child and still do! I am convinced that I learned a lot about cat body shapes and movement from watching cartoons drawn by talented studio artists.

Cartooning can be a relatively simple way of practising the basic shapes and movement of cats without the added pressure of trying to create realistic looking fur, eyes and so on. If you have not drawn cartoon animals for a while – and cats in particular – begin by looking at established images from comics or the internet, and use those to help you practise the stylised, often exaggerated shapes before moving on to cartooning your own cats at home, or big cats in zoos, from photographs, and – eventually – from life.

An art form in itself, cartooning is a great way to develop your observational skills. Understanding which parts of a cat's body best describe their character, and exaggerating those in a cartoon can really help when it comes to drawing more realistic cats; helping to understand a triangular-shaped nose, for example. Give it a go – drawing cartoons can be an enjoyable and creative way to capture the character of cats.

Cat Napping
One of our black-and-white tuxedo cats, Skunk, has a very long tail and huge paws. A cat tree hammock by the window is his favourite resting place and his sleepy expression is ideal for cartooning.

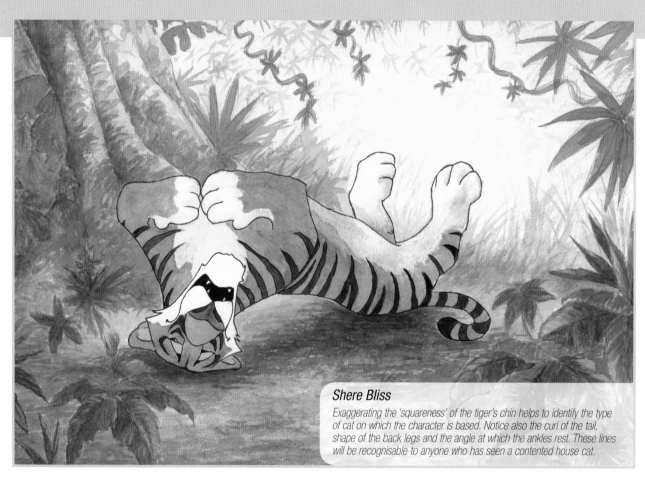

Shere Bliss
Exaggerating the 'squareness' of the tiger's chin helps to identify the type of cat on which the character is based. Notice also the curl of the tail, shape of the back legs and the angle at which the ankles rest. These lines will be recognisable to anyone who has seen a contented house cat.

Meow!

*This ink pen and watercolour wash cartoon
of my cat Oscar is a tribute to many of my
favourite MGM cartoons.*

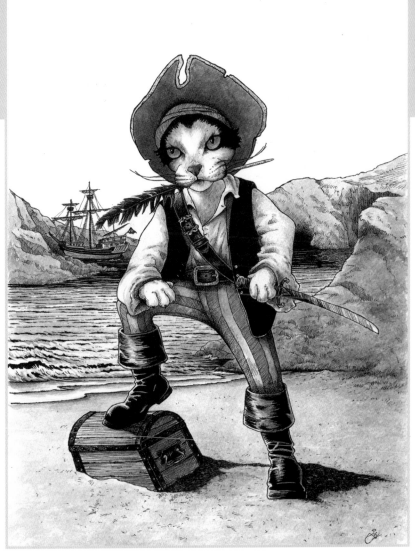

The Curse of the Black Feather

*Ink pen and Indian ink wash is the ideal medium
for an illustration in a comic book or graphic
novel. Featuring Oscar Wildecat and his favourite
possession, a feather, this could well be the cover
page of a great feline adventure story.*

Sketching from life

I think if pushed just a little, most people could draw a reasonable representation of a domestic cat, tiger or lion in cartoon form from memory. After all, many of us regularly did just that as children. The leap from drawing cartoon cats to more realistic ones need not be as great as you might think. Perhaps the confidence we had as children drawing cartoons wanes a little as we grow up and try to be more sophisticated in our approach to art.

Observation

For me, the key to sketching animals from life is observation. Understandably, a lot of us tend to spend a lot of time – perhaps too much – looking at the world through a camera lens, mobile phone or iPad and, as a consequence, tend to 'see' rather than 'study' our subjects. Our brains are well able to hold visual information for longer than we might imagine. If someone were to show you a picture of an everyday object such as a table lamp for five or ten seconds, I am fairly confident that you could draw a reasonable representation of it after that short period of time while the visual image is in your head; perhaps for quite a long time afterwards.

One of the problems I find when taking students on big cat sketching days is that some try to make marks on the paper too soon, worrying perhaps that their subject might move or walk away before they have a chance to capture it in pencil. If we make an effort to stand and watch our feline subjects for a few minutes, without sketching or photographing them, we can take in so much more information about anatomy and the way the cats move than we can from a photograph alone.

Of course photographs can give you great back-up reference material to help in developing your initial sketches into finished artworks, allowing you to see greater detail in fur patterns, eyes and other features. Photographs can also be beneficial in helping you to practise sketching body shapes and poses, especially if you do not have your own live models at home, or are unable to visit zoos and sanctuaries on a regular basis.

A series of sketches from life. Spending time observing your subject will help to make initial sketches more complete. If the subject moves, use the time to add background elements such as foliage, trees and rocks as this will help you gain an insight into your subject's environment and improve the realism of any finished work you produce from the sketch.

Doodling and visual diaries

If you are like me, you will probably doodle on scraps of paper now and again; at work, talking on the telephone, or while watching something uninteresting on the television. I love doodling. I find it not only relaxing, but also a great, uninhibited way of making marks and building confidence when faced with an otherwise daunting white sheet of paper.

My sketchbooks are visual diaries. I won't pretend that I make an entry in my sketchbook diary every day, but I certainly do add something most days, even if it is just a simple doodle. Some days I will do multiple sketches to make up for those missing days. Like diaries, sketchbooks are wonderful to look back on, bringing back memories of ideas that might have been used, or have been forgotten; a reservoir of creative thoughts, images and notes which become a valuable resource any time that I need inspiration.

I believe that sketchbooks should be constant companions for all artists; I always travel with mine, along with pens and pencils, plus spares! An evening in a hotel room far from home would be boring without my sketchbook, in which I can doodle, make simple sketch notes of ideas for artworks, or even create complete illustrations with my ink pens.

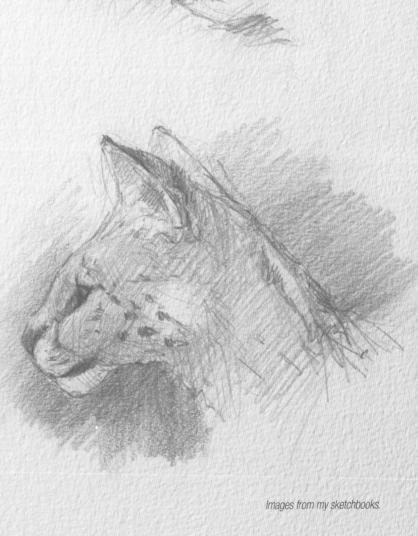

Images from my sketchbooks.

Get out there!

No trip to a zoo or animal sanctuary is ever complete without a sketchbook. Mine are hardback and spiral bound, and large enough to rest securely on my lap, which makes them easier to handle when sitting on the grass alongside an enclosure.

Before you face the potentially daunting prospect of sketching at a zoo in full public view, try the more relaxed approach of sketching your own cats – or those of family and friends – in the quieter and more private home environment. Domestic cats tend to spend a lot of time sleeping, which is a great way to begin sketching from life – the shapes are generally simpler, and there is more time for observation.

If your subject is being cooperative and not moving around too much, begin by positioning the head, represented by a circle, paying attention to the size and position, as this will probably be the focal point of your sketch. Use that time also to create a setting – grass, trees, rocks and so forth – that will enhance your sketch.

Remember that it is important to spend at least as much time between sketches observing the movement, anatomy and details as you do actually sketching, in order to build up your visual memory. You will then find that adding details such as noses, eyes and ears in the correct shapes and proportions becomes easier and easier, until it is second nature to you.

Once you are beginning to gain some confidence in sketching cats from life, try to find a sanctuary, rather than a public zoo, where you can spend a quieter day sketching. I tend to find that animals in conservancies are more visible and active than those in zoos.

House Cat

Catching your house cat napping is generally not difficult. Sketching him or her in the privacy of your own home is an excellent way to begin sketching from life with no pressure. You don't even have to show the finished piece to the sitter!

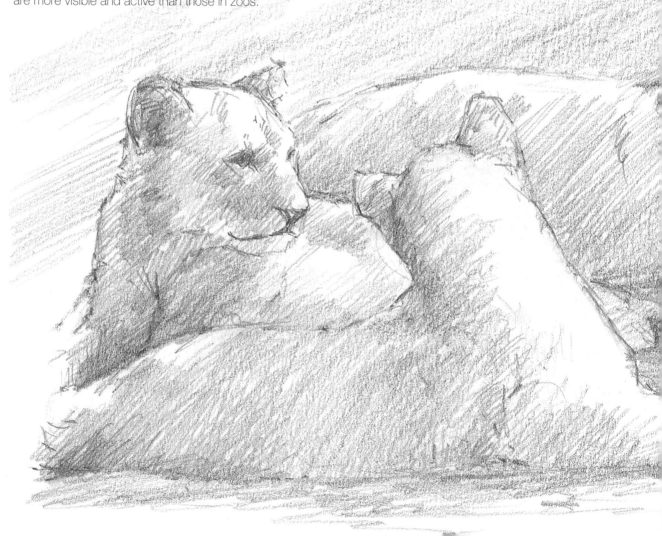

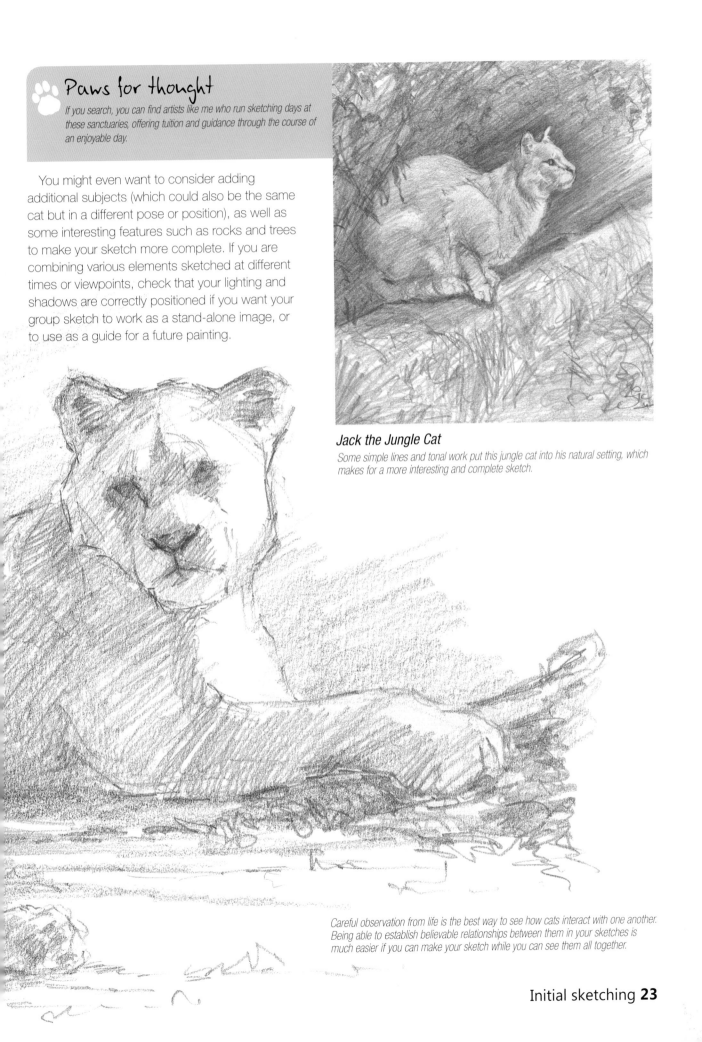

Paws for thought

If you search, you can find artists like me who run sketching days at these sanctuaries, offering tuition and guidance through the course of an enjoyable day.

You might even want to consider adding additional subjects (which could also be the same cat but in a different pose or position), as well as some interesting features such as rocks and trees to make your sketch more complete. If you are combining various elements sketched at different times or viewpoints, check that your lighting and shadows are correctly positioned if you want your group sketch to work as a stand-alone image, or to use as a guide for a future painting.

Jack the Jungle Cat
Some simple lines and tonal work put this jungle cat into his natural setting, which makes for a more interesting and complete sketch.

Careful observation from life is the best way to see how cats interact with one another. Being able to establish believable relationships between them in your sketches is much easier if you can make your sketch while you can see them all together.

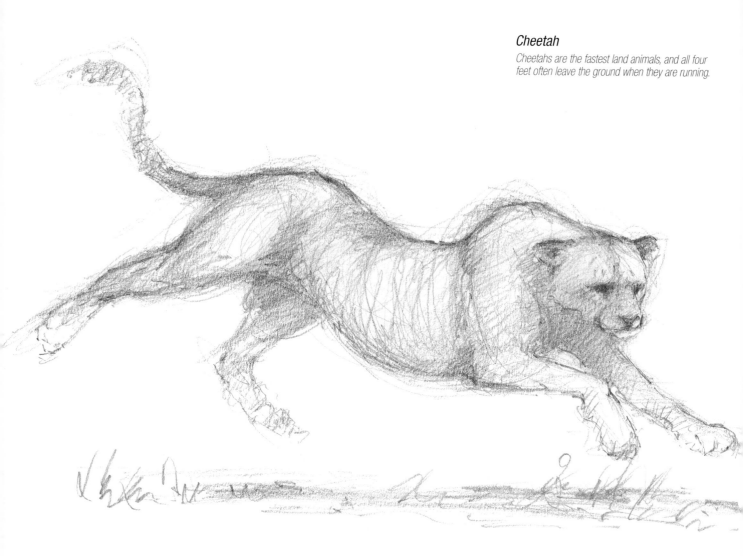

Movement and energy lines

At some point you will likely want to be able to sketch cats when they are doing something more active than sleeping – perhaps stalking, running or playing. For this you need to be quick. First of all forget about details like fur patterns or features and concentrate on the form instead. The method I use in this case is a light 'scribble sketch', holding the pencil at the non-drawing end for looser, less controlled lines.

This method allows me to establish shape and form very quickly, adding the shape of the back – the 'spine line' – along with some basic shading to show form and stronger lines around the head and muzzle. Most of this can be done after your subject has moved if you have spent time observing and remembering beforehand.

One of the advantages of sketching, often overlooked, is that while working out shapes and angles with your hand moving constantly on the paper, 'energy lines' are naturally created, as in the cheetah sketch shown above.

There may be a natural tendency to erase these marks and lines, both during the sketching process and after you have finished tidying up your work. However, unless your aim is to turn your sketch into a neater, more finished drawing or illustration, why not keep your underlying 'energy lines'? They can really give an impression of movement and vitality if left to underpin the sketch.

Paws for thought

There is more information on the spine line on page 17.

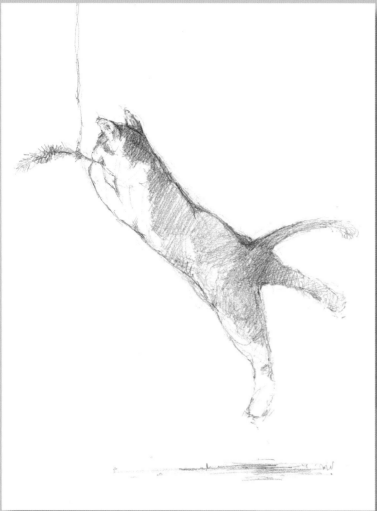

Jumping

When sketching jumping cats, try moving the spine line away from the vertical; the more acute the angle, the more unbalanced the subject becomes, creating an impression of motion. Adding some horizontal shading a little way from the cat's feet will reinforce the idea of a jumping movement.

In both cases I try to leave the back feet, which are usually moving the most, a little looser and less refined in the sketch, whilst the head, which remains relatively still, is rendered more sharply. I also try to show a fairly strong spine line to reinforce the angle of movement.

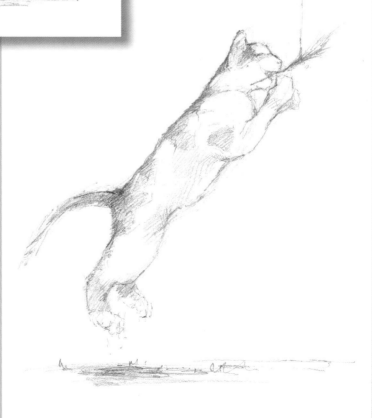

Preparatory sketching

For me, the basis of a good painting, drawing or illustration is preparation. The preparatory sketch is a good way to work out important elements for the finished artwork – elements like composition, tone and lighting. I often think of preparatory sketches as extended doodles, using ink over a rather loose pencil sketch to show stronger tonal values and more details.

Unlike the looser initial sketches discussed on pages 16–25, preparatory sketches are more developed, as they are intended to be used as part of a finished painting. Sometimes of course, this extended doodle will turn out to be a finished drawing in its own right, as it is easy to become absorbed in the act of scribbling with a pen and get carried away. Naturally, this is all part of the fun!

Materials for preparatory sketching

This chapter explains the materials and techniques involved in preparatory sketching – that is, the sketches that will form part of your finished artwork. These may prove successful enough that you choose to keep them as artworks in their own right. Whatever the result, it is important to use good-quality materials.

Pens I generally use permanent, waterproof ink pens that have a self-contained ink chamber. There is a wide range of nib sizes available; the nibs often being fibre tips or very fine plastic tubes of varying diameters which allow the ink to pass through. I use a fine 0.2mm nib for most of my detailed work, going up to a slightly broader 0.5mm nib for shading larger areas. There are even pens with brush nibs for blocking in very dark areas.

Paper surface Ink pens can be used on a variety of papers, from textured watercolour paper to smoother cartridge paper to very smooth illustration papers and boards. Interesting tones and atmospheric effects can also be created with ink pens on brown kraft paper (see *Kit-Ten-Katmun* on page 5 for an example) or 'antiqued' card (see *Sekhmet* on page 8).

Important features

Whether creating a portrait or the whole body of a cat in your artwork, it is important to depict the facial features correctly and to keep the ears, eyes, nose and mouth balanced within the overall head.

Basic geometric shapes – circles, lines and triangles – will help to ensure you do not create crooked noses or misaligned eyes. This is an age-old concept, first put forward by Leonardo Da Vinci. The image to the right shows how it can be applied to cats.

Paws, whiskers and tails are not facial features, but they are important focal points, so help with drawing these body parts is also included in this section.

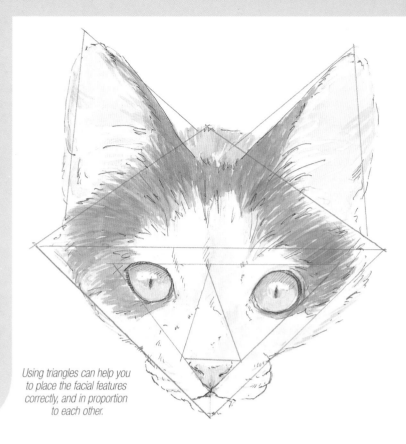

Using triangles can help you to place the facial features correctly, and in proportion to each other.

Ears

Most domestic cats' ears are quite triangular in shape, whereas big cats, such as lions and tigers, tend to have more rounded ears. However, I usually begin with the basic triangle ear shape for all my sketches, and then round off the tops off the ears accordingly; this will help me to keep both ears balanced and equally sized.

When shading cats' ears, remember that they are concave shell-like shapes, so that they will be slightly darker in the middle part nearest the head.

Cats' ears are able to move around independently, like small radar dishes, picking up sounds and sensing their environment all round. The ears can also fold back against the head at a join near the head, encased in a flap of skin called the cutaneous pouch. This is an essential part of the ear, often overlooked when drawing.

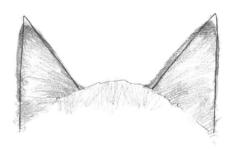

Triangles come in useful for placing the ears.

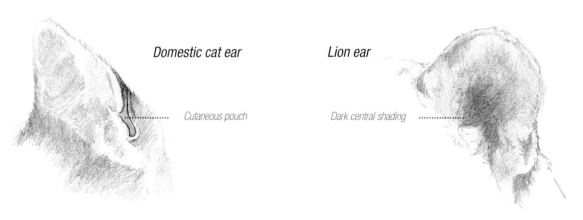

Domestic cat ear

Cutaneous pouch ··············

Lion ear

Dark central shading ··············

Noses

Like cats' ears, feline nose pads (also called 'leathers') have a basic triangular shape, and knowing this will help you to draw and paint the nose successfully at different angles.

This approach can be used when drawing noses at different angles – simply curve the straight lines of the triangle when drawing the nose leather from different viewpoints, as in the three-quarter face example below.

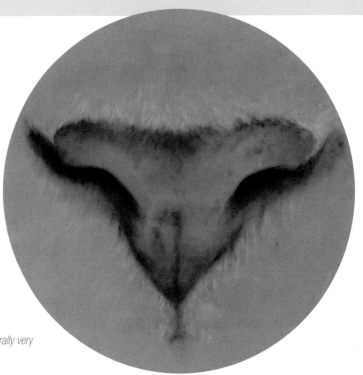

Leopard nose
The noses of big cats are structurally very similar to those of domestic cats.

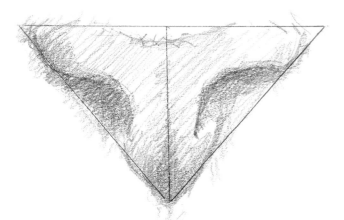

Nose leather
from the front

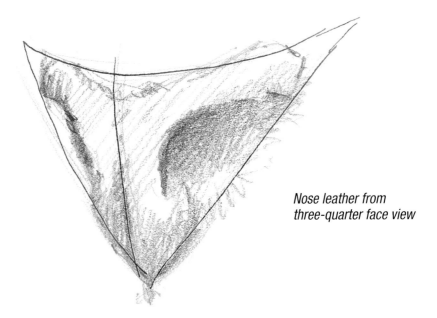

Nose leather from
three-quarter face view

Paws for thought

Why does the fur on a black cat's nose shine? The fur grows down towards the tip of the nose, reflecting light from above, whereas fur above the bridge of the nose grows upwards, absorbing the light.

Eyes

Cats of all types are often thought of to have the most beautiful, if sometimes deadly, eyes in the animal kingdom.

Most artists would agree that capturing light and life in the subject's eyes is an important element in any finished artwork. Armed with just a small amount of anatomical knowledge, remembering three fundamental variables (shadows, highlights, reflections) and a little practice, anyone can draw or paint realistic-looking cats' eyes.

The profile view of a cat's eye (see right) shows how light coming from above (such as sunlight or moonlight) creates and affects shadows, highlights and reflections in the eye, which are the key factors that we, as artists need to consider.

With the forward facing view (see below), you can see how the shadows, highlights and reflections combine to create a realistic, shiny feline eye.

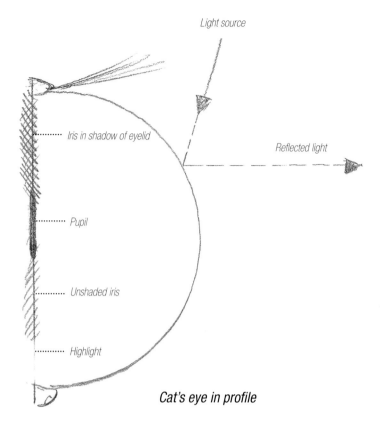

Light source

Iris in shadow of eyelid

Reflected light

Pupil

Unshaded iris

Highlight

Cat's eye in profile

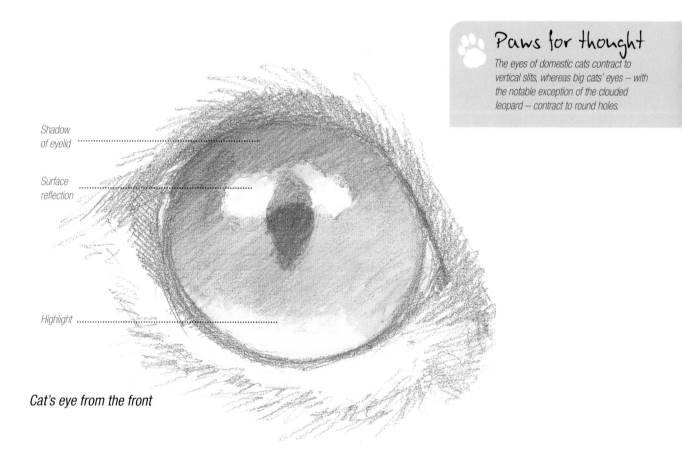

Shadow of eyelid

Surface reflection

Highlight

Cat's eye from the front

> ### Paws for thought
> The eyes of domestic cats contract to vertical slits, whereas big cats' eyes – with the notable exception of the clouded leopard – contract to round holes.

Paws

There is no need to be apprehensive about cats' lovely paws. Once you know how, paws are easy to draw and paint. Their presence will enhance your painting, especially the lovely soft, rubbery pads underneath which enable cats to hunt silently.

Paw pads act like shock-absorbing cushions. They are usually the same colour as the nose leather. There are four digital pads and one larger, heart-shaped pad on each foot. In addition, there are non weight-bearing pads, such as the front dew claws and the small pea-shaped wrist pads which provide additional traction for quick changes of direction or speed.

Cats have five toes on the front paws (including the dew claw on the side) and four toes on the back paws. It may be helpful to draw faint lines as 'fingers' first to help guide you in fleshing the toes and paws out further.

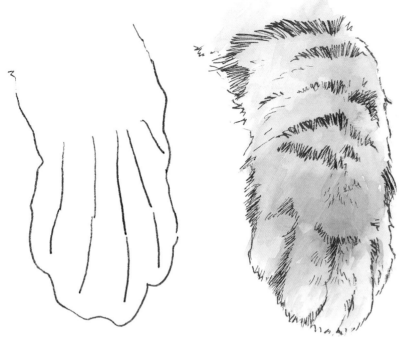

The five lines above represent the underlying bones – they will help you to picture the structure of the paw under the fur and flesh, seen right.

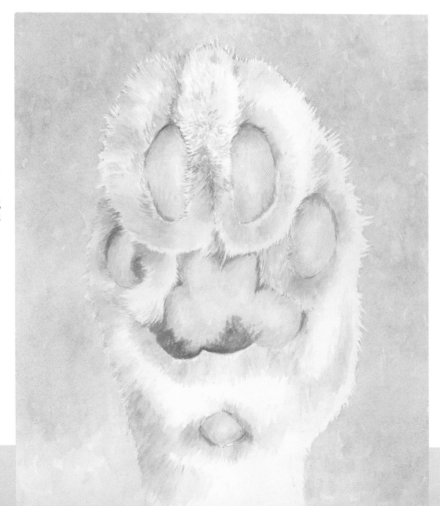

Oscar's Foot

This watercolour painting shows the underside of a domestic cat's foot, revealing the soft rubbery pads.

Whiskers

Cats' whiskers (*vibrissae*) are highly sensitive organs, and they appear not only on the upper lips, but also sprouting from the cheeks, the chin and above the eyes.

When a cat is relaxed, its whiskers droop. They point forwards when it is being curious or friendly, and lie flat towards the neck when the cat is showing aggression, or hunting. The attitude of cats' whiskers, and how they are portrayed in your painting and drawing, is important in showing the 'mood' of the animal.

There are four rows of whiskers on each side of the upper lip, totalling twenty or more. When you are painting the whiskers, remember that they are generally more than twice the thickness of regular hairs, shorter and finer at the front; longer and thicker at the rear.

Eye whiskers

Cheek and chin whiskers

Tails

Like whiskers, cats' tails can communicate a lot about their attitude. Cats that are happy and confident will walk around with their tails held high. The more aggressive or threatening the behaviour, then the lower the tail is carried, for example when hunting.

Tails are also used for balancing, particularly those of arboreal cats that live in trees, such as the clouded leopard, or those negotiating their way around precarious mountain slopes, such as the snow leopard or mountain lion. In these cases the tail is usually a lot longer than in ground-dwelling cats.

Tails and mood

Happy, playful cats will hold their tails upright, as shown in the image above right. When hunting, as in the lower picture, the tail will be held low, and will flick up at the end.

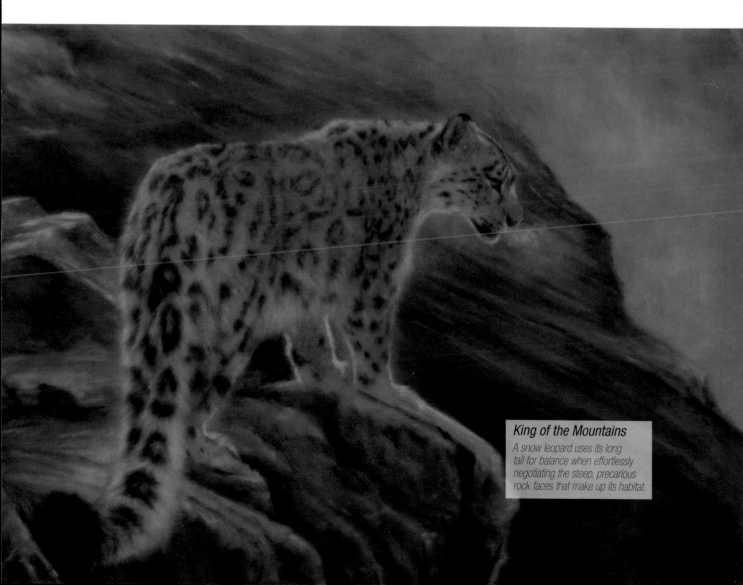

King of the Mountains

A snow leopard uses its long tail for balance when effortlessly negotiating the steep, precarious rock faces that make up its habitat.

Composition

Tone in composition

For me, tonal value is probably the most important aspect of a drawing or painting. Tonal values (darks and lights) create three-dimensional forms within shapes. If you add a dark tone (shadow), midtone and light tone (highlight) to a circle, then you will get a sphere.

Tonal values can also create depth in an artwork by using stronger tones (darker and lighter) in foreground elements, and less strong tones (paler greys for example) in backgrounds. This is known as 'aerial perspective'; the further away an object is, then the paler and less detailed it appears.

Light and atmosphere

Tone can also be used to create interesting lighting, atmosphere and even a sense of drama in your artwork. Lighter tones do not always have to be reserved for background elements. Look at the two examples of the same white lion below. Because both the subject and the background have the same white tone, the upper picture looks a little flat, especially when viewed from a distance. In the lower image, darkening the background also adds strength to the lion, as the contrasting strong tones (dark and light) make the shapes easier to see, giving impact.

🐾 Paws for thought

There is more information on tone on pages 44–45.

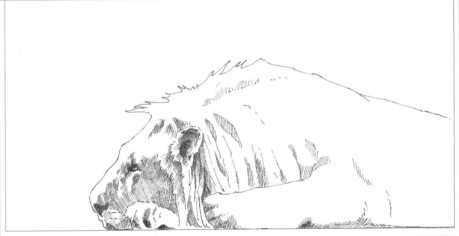

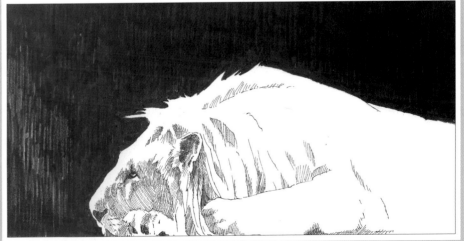

Themba
White lion sketches made in ink pen. The dark background in the lower picture was added with a brush-tipped ink pen.

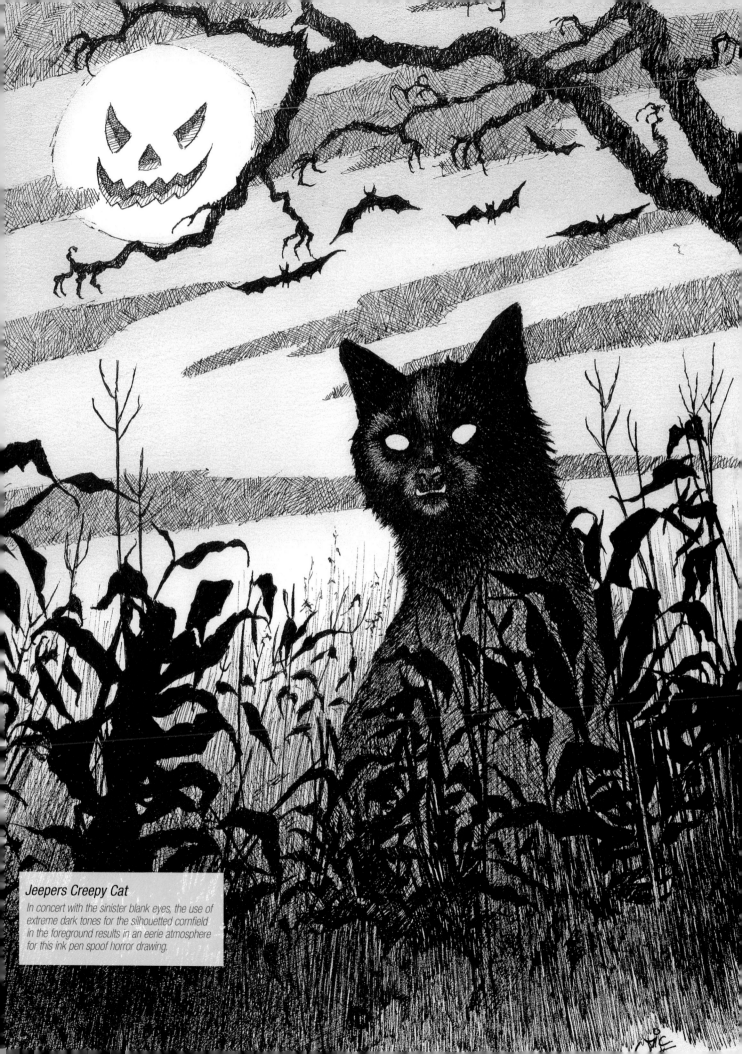

Jeepers Creepy Cat

In concert with the sinister blank eyes, the use of extreme dark tones for the silhouetted cornfield in the foreground results in an eerie atmosphere for this ink pen spoof horror drawing.

Use of setting in composition

If you are drawing and painting cats using references from zoos or conservancies, you may well want to create more natural habitats for your subject to reside in. Adding suitable backgrounds can make for a more interesting artwork, especially if you are painting more of the cat than you would in a portrait. If you decide to add a background it should, of course, be appropriate to the species involved.

Whenever I visit a zoo, I always head for the tropical plant exhibits, where I know I can see and photograph examples of plants from across the globe, and they are usually labelled to show the name of the plant and its country of origin; this very helpful for the animal artist, assuming the origin of your cat is also known.

Of course, some of my artwork, especially of domestic cats, may include objects and backgrounds from anywhere that stirs my imagination, from household objects, furniture, trees and even my own studio. However you decide to enhance your own feline artwork, be creative and have fun!

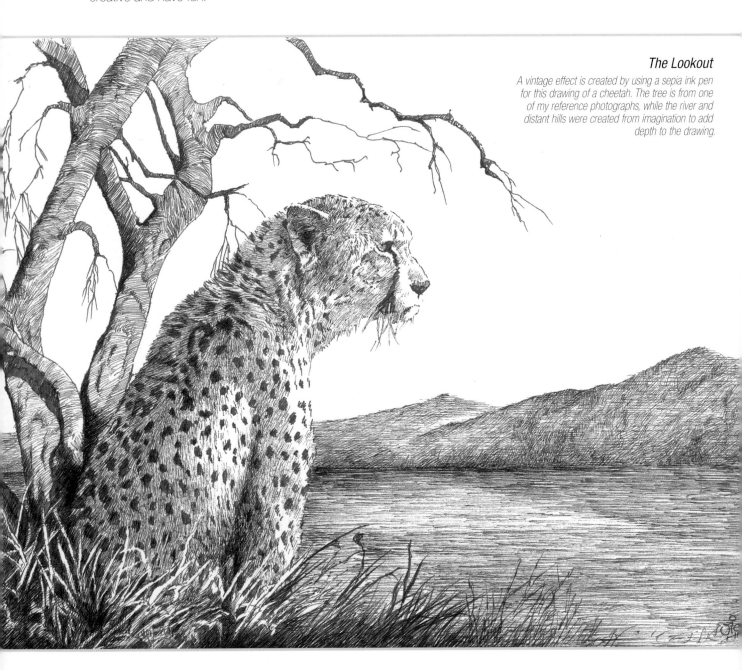

The Lookout

A vintage effect is created by using a sepia ink pen for this drawing of a cheetah. The tree is from one of my reference photographs, while the river and distant hills were created from imagination to add depth to the drawing.

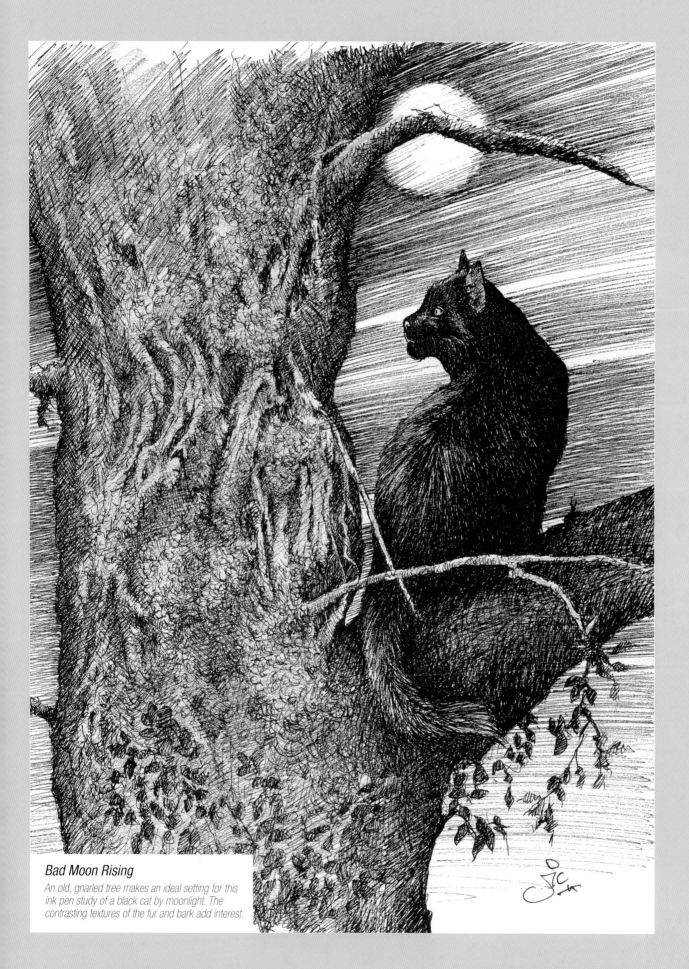

Bad Moon Rising

An old, gnarled tree makes an ideal setting for this ink pen study of a black cat by moonlight. The contrasting textures of the fur and bark add interest.

Drawing as artwork

Having explored the joys and benefits of pencil sketching, and learned about using ink pens to enhance those sketches, it is worth emphasising that pencils and pens, whether used on their own or in combination, can also be used to create lovely finished artworks in their own right.

 Finished drawn artwork does not necessarily have to include a lot of fine detail, but to differentiate it from a preparatory sketch, it is likely to include some further refinements of texture, detail and shading.

 Drawing is mostly associated with monochrome work. But of course, drawing with coloured pencils is also a very popular technique, as is drawing using coloured pens. If you want to create something a little different using the tonal strength and detail of an ink pen, without colours, try sepia pens to give an old-fashioned feel to your artwork.

 These steps into colour mean that this chapter serves as a bridge between our earlier sketching and the various colour artworks in different media we look at later.

Ben
Ink pen and graphite pencil drawing with foliage added from various reference photographs to create a natural setting. Note the use of haphazard hatching in the background to create the impression of a chaotic rainforest behind this clouded leopard.

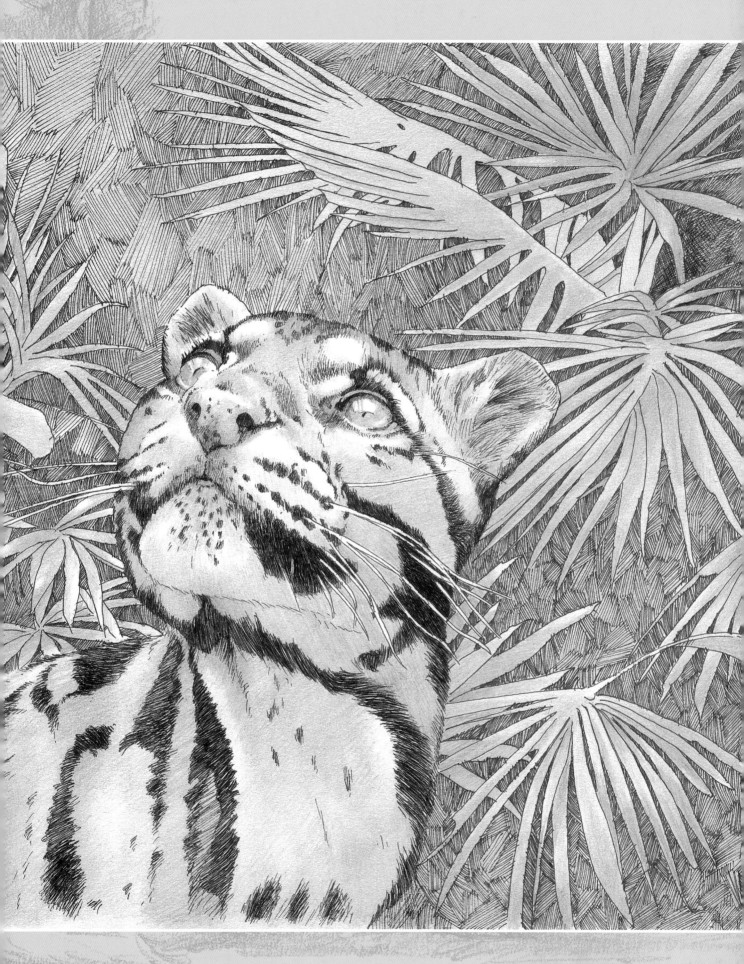

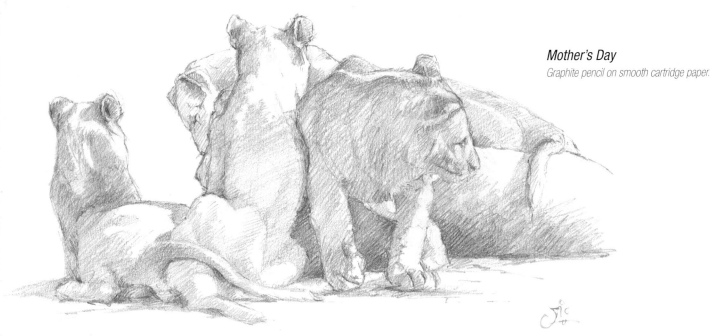

Mother's Day
Graphite pencil on smooth cartridge paper.

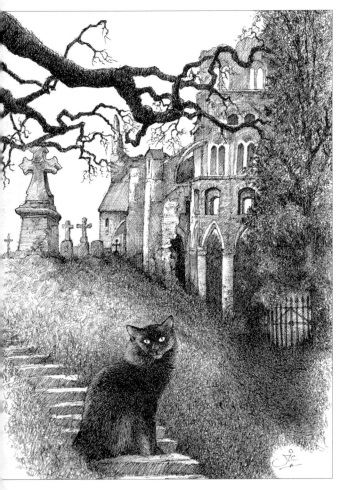

Le Chat de l'Abbaye
Ink pen on hot-pressed watercolour paper.

What Now?
Ink pen with graphite pencil shading on
hot-pressed watercolour paper

Directional hatching
Use single directional hatching (left of image) for graduating tones such as skies, and overlay in different directions for more intense tones (right).

Directional curved hatching
Fur can be described very well by following the shape of the object and altering the angle of your hatching as you work.

Haphazard hatching
Small areas of single directional hatching work well for broken, rocky textures.

Black and white artwork

Monochrome work lends itself to atmospheric finished artworks, and there are a number of different approaches that you can take, from finely detailed pen work to a looser line and wash approach.

Fine detail with pen and pencil

If I want to create a drawing with fine details, I will generally use an ink pen with a very fine nib. This allows me to build form with sharp multi-directional hatching for stonework and trees, delicate overlapping squiggles for detailed foliage, and looser directional hatching to show fine fur textures. All these techniques are used in *Le Chat de l'Abbaye*, which I created using various references from Normandy, France and my own cat, Squirrel. The pictures on this page explain each type of hatching in more detail.

I tend to use graphite pencils for finished artwork if I want a more subtle looking finish. Pencils are ideal for creating more gentle lighting and softer tones than ink pens. The absence of 'energy lines' and other sketchy marks, along with more clearly defined edges, makes *Mother's Day* more of a finished drawing than the sketches shown earlier (see pages 16–21).

Ink pens and graphite pencils are also perfect partners, as we have seen. As well as enhancing a pencil sketch with ink pens, ink pen drawings can be enhanced by the softer tonal shading of a pencil. This combination allows you to utilise the qualities of both media: the strength and detail of the pen given more depth and subtlety with the softer pencil shading. This technique is used to create the white soft fur and more defined black splodges in *What Now?*, featuring a young Oscar Wildecat.

Squiggle hatching
I use this sort of hatching to suggest the mass of complex background shapes like foliage.

Contour hatching
This technique, where the marks follow the shape of the object, is useful for describing objects such as trees.

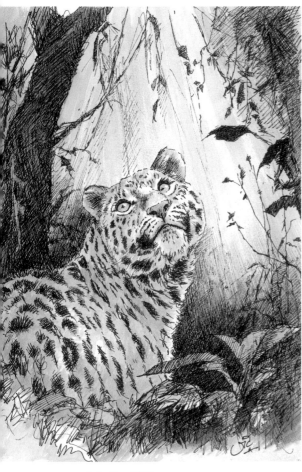

Into the Wild
This sketch of an Amur leopard was worked in ink pen. Once it had dried, dilute ink was washed over to produce the midtones.

Pride and Power
As with Into the Wild, *I used washes of dilute ink over a preparatory ink pen sketch to produce the tonal work.*

Pen and wash

Ink pen and wash is a very old technique, used in Chinese landscape painting for example. Applying flat, even washes of Indian ink over an ink pen drawing adds form and tonal atmosphere, even a dramatic mood to your drawing. Rembrandt famously used this pen and wash technique in his lion drawings, among others.

Paws for thought
Make sure the ink in your pen is permanent and waterproof if you intend to use a wash of colour over your ink drawing, or it will smudge.

Opposite
Dark Angel
An Indian ink wash over this ink pen illustration adds softer tones and enhances the textures.

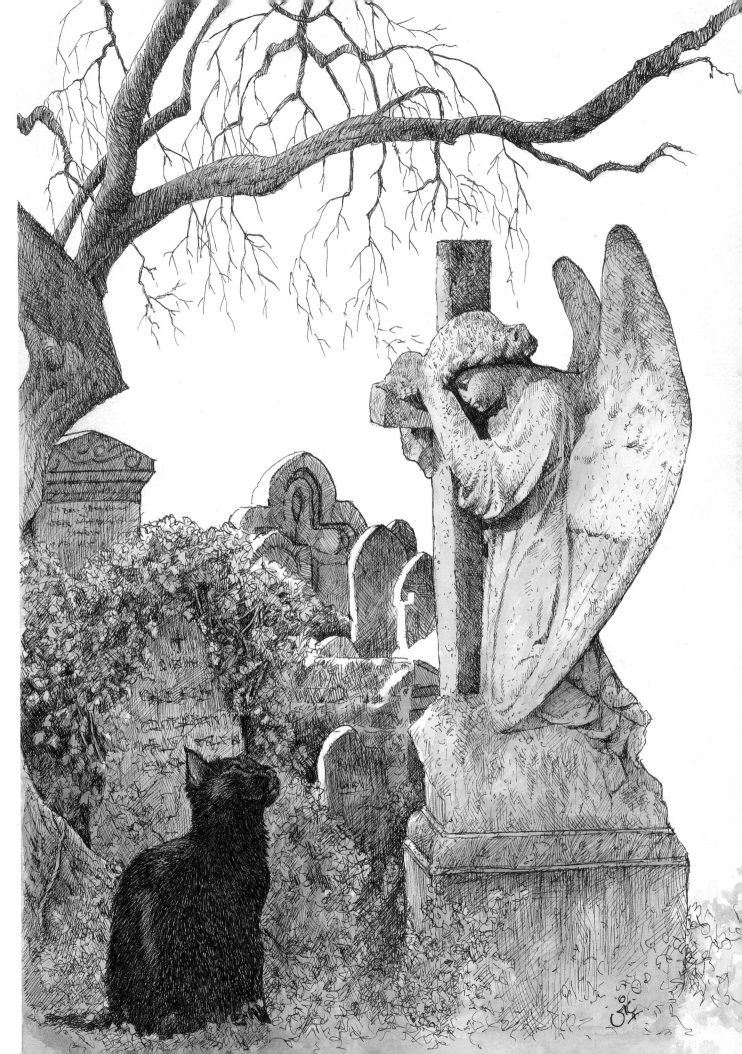

Colour and tone

The relationship between colour and tone has been the subject of whole books, some of which can be very technical. As far as this book is concerned, the basic guidelines on these pages will help to demonstrate how to understand and control the use of colour in our drawings and paintings.

For the majority of my coloured cat artworks I tend to use a limited palette, restricted to natural warm colours – yellows, oranges and browns, and cool colours – greys, blues and violets. I find that this alleviates the need for mixing different hues.

Colour tinting and shading

Any colour can be lightened (tinted) with various amounts of white added. Conversely, any of the colours can be darkened (shaded) with various amounts of black. As a result, that one colour can have a wide variety of tonal values. The illustrations below demonstrate these different approaches. If your subject's fur is slightly darker in areas, add a little black to darken it, or add some white or off-white to show the highlights in his brown fur. Both help to create interesting and eye-catching tonal effects.

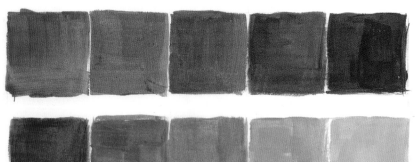

Shading
The left-most swatch shows chromium oxide green acrylic straight from the tube. Incrementally more ivory black has been added to the swatches further right to darken the colour.

Tinting
Here, the left-most swatch shows cobalt blue acrylic straight from the tube. This time, incrementally more titanium white has been added to the swatches further right to lighten the colour.

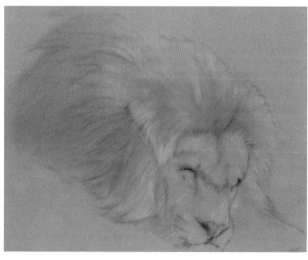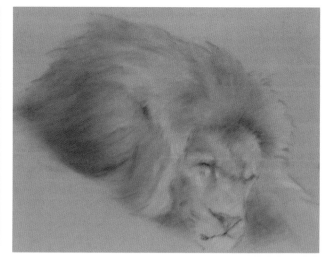

Tinting and shading
Both of these lions were worked in pastel on velour. The left-hand illustration shows ivory pastel worked over a brown base for a lighter tint, while the right-hand lion has black worked under the brown to create a darker shade to the finished piece.

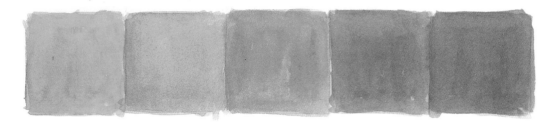

Toning

Cadmium red watercolour glazes have been added over increasingly darker grey squares made using different tones of Indian ink.

Toning

One of the other ways of changing colours, often more pleasing to the eye than using strong bright colours is to add various greys, from dark to light. Where adding black is shading, and adding white tinting, adding grey is 'toning'. Many household emulsion paints are produced by adding greys to existing colours, which softens their appearance.

By first creating a grey painting and adding transparent layers of colour over, these colours become muted to a greater or lesser extent, depending on the number of layers. This is a great technique for producing gentler illustrations, for children's books for example. The cover of this book was also created with this approach.

Toning

The left-hand illustration of Fleche, a French kitten whom we met on holiday in Normandy, is worked purely in Indian ink, with soft grey tones achieved by diluting the ink with deionised water. The right-hand illustration has overlaying watercolour washes to create subtle colour tones.

PAINTING CATS

A variety of different painting media can be used to paint cats, and if you already paint, there may be a particular medium that you are particularly comfortable using. In this section I will be using four media, a couple of which might not be immediately thought of as painting materials.

When it comes to painting cats, there are different textures to consider, from fur to skin – the latter transparent in the ears, fleshy in the nose leather and pads – and of course eyes. When painting the varied colours in the eyes, creating realistic highlights and reflections is so important, whichever medium is used. Then there are the whiskers, an integral part of your feline artwork, which can make or break your finished painting.

From line painting to glazing, masking to overlaying, and even mixing media, you will find all the techniques you need in the following sections. I hope you will have fun trying the step by step demonstrations for yourself, before going on to paint your own cats, or those from your local zoos and sanctuaries.

Scarface
Painted with pastels on soft velour. Male lions – when they are not sleeping – often spar with one another. While their skirmishes are not always serious, they tend to accumulate scars as they get older. Remembering to include these scars in your painting will add realism.

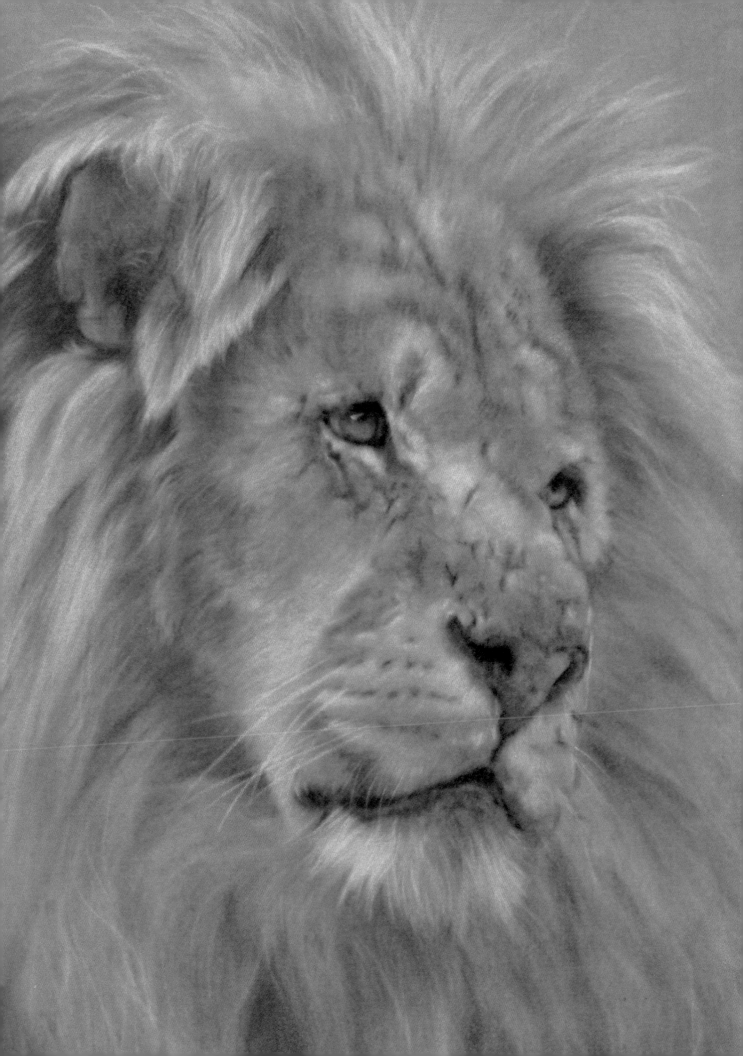

Watercolours

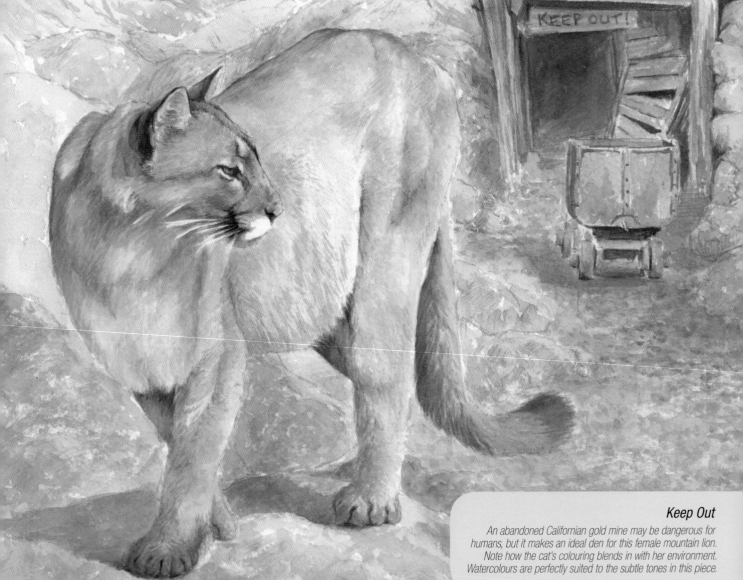

Watercolours have been used to paint and illustrate wildlife since the sixteenth century. There is something about their softness and luminous quality that makes watercolours so appealing when painting cats. They suit many styles, from realistic artwork to illustration and field studies, thanks to their portability and quick drying time.

However, the drying time and the fact that pigment can still be lifted out once the paint is dry also make watercolours one of the more difficult media to master. Once you have learned the techniques and practiced a little, watercolours can also be a joy to work with.

Keep Out

An abandoned Californian gold mine may be dangerous for humans, but it makes an ideal den for this female mountain lion. Note how the cat's colouring blends in with her environment. Watercolours are perfectly suited to the subtle tones in this piece.

Materials for watercolour painting

Watercolour paper The usual support for watercolours is paper, of varying thickness and texture. I tend to use reasonably heavy paper around 300gsm (140lb) to 425 gsm (200lb) as this will hold a lot of water without buckling. I prefer a Not (short for 'Not hot pressed') paper, which has a slightly textured surface.

Watercolour paints Go for the best you can afford in your finished artwork. Cheap brands have less pigment, but are fine for practice. A good starting palette for cat painting is burnt umber, burnt sienna, Payne's gray, cadmium yellow, French ultramarine, cobalt blue, rose madder and sap green.

Watercolour brushes Sable hair brushes are the best to use with watercolour paints, but can be expensive. A good quality synthetic or semi-synthetic will work well, as long as they retain their shape and hold plenty of paint. A size 20 round, size 6 round, size 4 round, 25mm (1in) flat, and a 12mm (½in) flat will cover most eventualities.

Water pot Anything that will hold water is fine. A transparent container will allow you to see when your water needs changing more easily.

Tap water Most tap water will be fine to use, unless it is very hard, in which case it may reduce the flow of your paint. If you are unsure, use bottled water.

Palette It does not matter too much whether you use a plastic or ceramic palette, but a ceramic one will be easier to clean and will not stain over time.

Masking fluid and brush I use blue masking fluid, because it is easier to see on white paper, and apply it with a designated masking fluid brush. This is harder than a watercolour brush, which may become damaged by masking fluid drying in the hairs.

Kitchen paper Ideal for cleaning and drying brushes. Kitchen paper is also useful for lifting out wet paint and creating special effects.

2B pencil This pencil is light enough for the initial sketch and to be erased easily as you begin painting.

Dust-free eraser My preferred tool for erasing; the bits of rubber that come away with use clump together, making it more clean to use than a hard plastic eraser.

Easel, masking tape and board A sturdy easel (table or standing) and a smooth board will hold your work steady. Use a medium tacky masking tape to secure your paper to the board as this will be less likely to tear the surface of your paper when you remove it.

Watercolour techniques

Let's now have a look at some of the fundamental techniques used in watercolour painting which will help you to create a successful artwork.

Preparing watercolour paint

In watercolour painting, planning is especially important. Before you apply paint to paper, you should prepare enough of the colour or mix to cover the particular area quickly and smoothly, and make sure it is at the consistency you want.

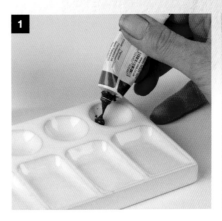

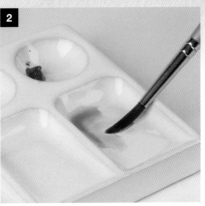

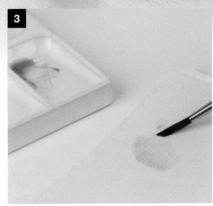

1 Squeeze out a tiny amount of paint into a clean well on your palette.

2 Wet the brush you will use to paint with, then touch it into the paint in the well, and carry it over to the mixing area.

3 Pick up the paint from the mixing area and test it on a spare piece of watercolour paper to check the consistency and colour. Watercolour will dry slightly lighter than it appears while wet, so take this into account when preparing the paint.

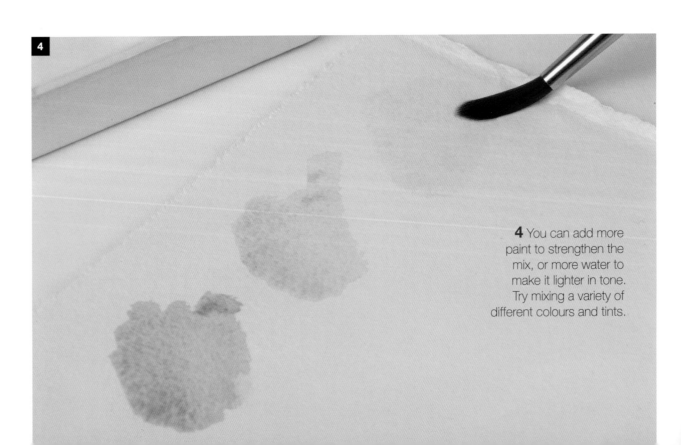

4 You can add more paint to strengthen the mix, or more water to make it lighter in tone. Try mixing a variety of different colours and tints.

Wet on dry

The most basic of watercolour techniques, this is simply getting the paint onto the paper in a controlled way.

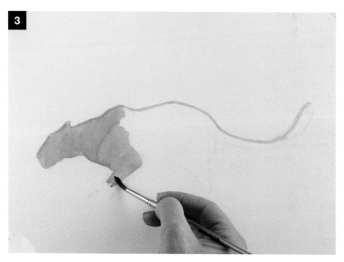

1 Tape your paper to the board, set the board on the angled easel – which should be set at around fifteen degrees off vertical, as shown. Prepare plenty of paint – more than you think you'll need, as running out halfway can cause a lot of problems.

2 Use a 2B pencil to sketch a small cat shape on your paper. Wet your brush in the water pot. Wipe the brush on the edge of the water pot to remove dripping water, then roll it through the prepared paint on the palette. Holding the brush halfway up as shown, begin to draw along the top edge of the shape. Hold the brush at a constant angle and drag the paint along by moving your arm, not your wrist. Use the point of the brush to get a crisp line at the border of the shape.

3 Working quickly, reload the brush – it's important not to let the paint run out as you work, or you will pick up the texture of the paper and create dry brush marks – and use the whole length of the bristles to apply the paint quickly into the body of the shape.

4 Continue filling in the shape, using the edge and point of the brush as appropriate. The key to painting watercolour is preparation – it is a medium that rewards calm, speedy work and can be spoiled if you do not work smoothly and quickly.

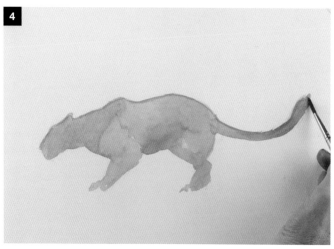

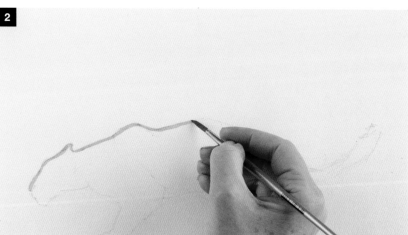

Wet-in-wet washes and lifting out

Adding paint to paper that is already wet can be difficult to control or predict, but not quite knowing what will happen as the paint dries is also one of the fun elements of watercolour painting.

Using kitchen paper or other absorbent materials and objects is a great way of creating interesting effects in wet watercolour washes. In this example, I use a round jar lid wrapped in kitchen paper to lift out a bright full moon from the night sky around my cat, Marley.

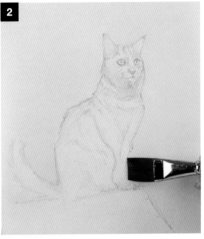
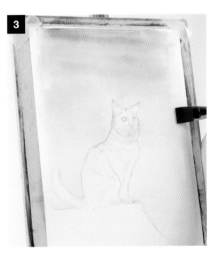

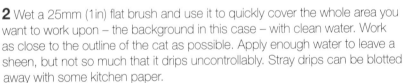

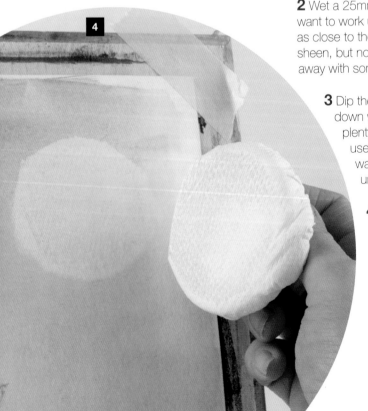

1 Secure your sketch in place on the board with masking tape, then place the board on the easel. Prepare a well of relatively strong French ultramarine, diluted just until it flows in the well. Next, wrap a jam jar lid (or similar-sized round object) tightly in kitchen paper as shown – one side should be smooth, with the rest gathered in a handle behind. It should look a little like a mushroom. The smooth side will be used to lift out the moon from the background.

2 Wet a 25mm (1in) flat brush and use it to quickly cover the whole area you want to work upon – the background in this case – with clean water. Work as close to the outline of the cat as possible. Apply enough water to leave a sheen, but not so much that it drips uncontrollably. Stray drips can be blotted away with some kitchen paper.

3 Dip the brush straight into the well of colour and, working from the top down with broad horizontal strokes, paint in the background. Pick up plenty of paint in order to avoid having to reload the brush, and try to use as few strokes as possible – do not over-brush or fiddle; let the water do the work of dispersing the pigment for you. Work down until the paint runs out – probably about halfway down the sky.

4 Quickly pick up your wrapped jam jar lid and press the smooth side firmly onto the surface where you want the moon to sit. Hold it in place for a few seconds to absorb as much paint as possible, then lift it directly away from the surface. Allow the painting to dry completely before continuing.

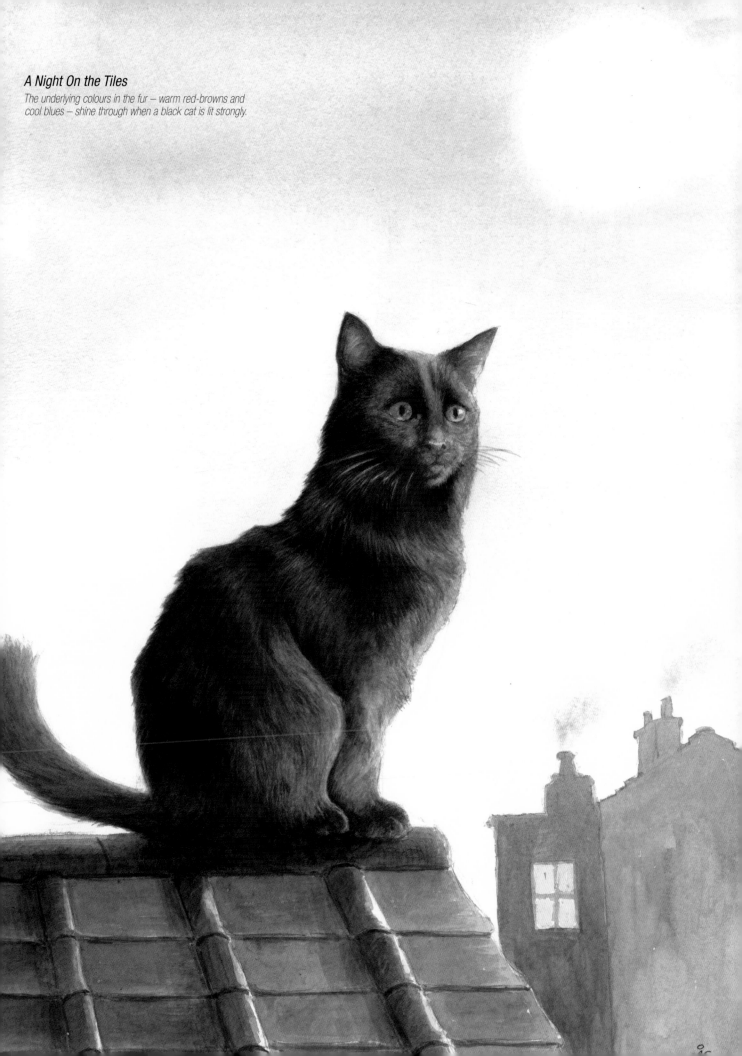

A Night On the Tiles

The underlying colours in the fur – warm red-browns and cool blues – shine through when a black cat is lit strongly.

Masking

Masking fluid is used to protect areas of the painting that you want to keep as the paper colour – usually white – such as edges of fur, reflections in the eyes and whiskers. This saves you having to meticulously paint around these fine shapes. Use a dedicated masking fluid brush with stiff, synthetic bristles as this will be easier to clean after use. I recommend using a tinted masking fluid, such as blue, so that you can easily see where you have applied it. In this demonstration, I will show how to use masking fluid to create the whiskers on Narnia the white tiger.

1 Complete your sketch, place it on the board and use masking tape to hold it in place. Place the board on the easel. Masking fluid can settle in storage, so shake your bottle vigorously before you begin.

2 Pick up some masking fluid and prepare it like a watercolour paint in a separate well. Use an old brush, as the fluid can damage your best brushes quickly. Masking fluid dries very quickly, so for very fine lines like whiskers, it is best to dilute it to roughly equal parts masking fluid and water.

3 Dampen your masking fluid brush and wipe a little hand soap on the bristles. This helps prevent the fluid clinging to the bristles as you apply it. Pick up a little of the diluted masking fluid from the well, and apply it to the surface where you want to preserve the white of the paper – the whiskers, in this example. Work carefully – any blobs or thick lines placed at this stage will show when you remove the masking fluid. Don't panic if you do make a mistake – simply wait for the fluid to dry, rub it away with a clean finger, and start again.

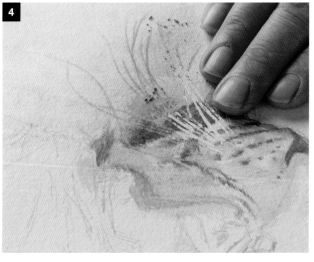

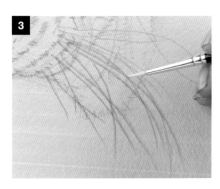

4 Allow the masking fluid to dry and then paint your picture. Once you have finished applying the masking fluid, rinse your brushes thoroughly in soapy water. Once the painting is dry, use a clean, dry finger to carefully rub away the masking fluid to reveal the white surface of the clean paper.

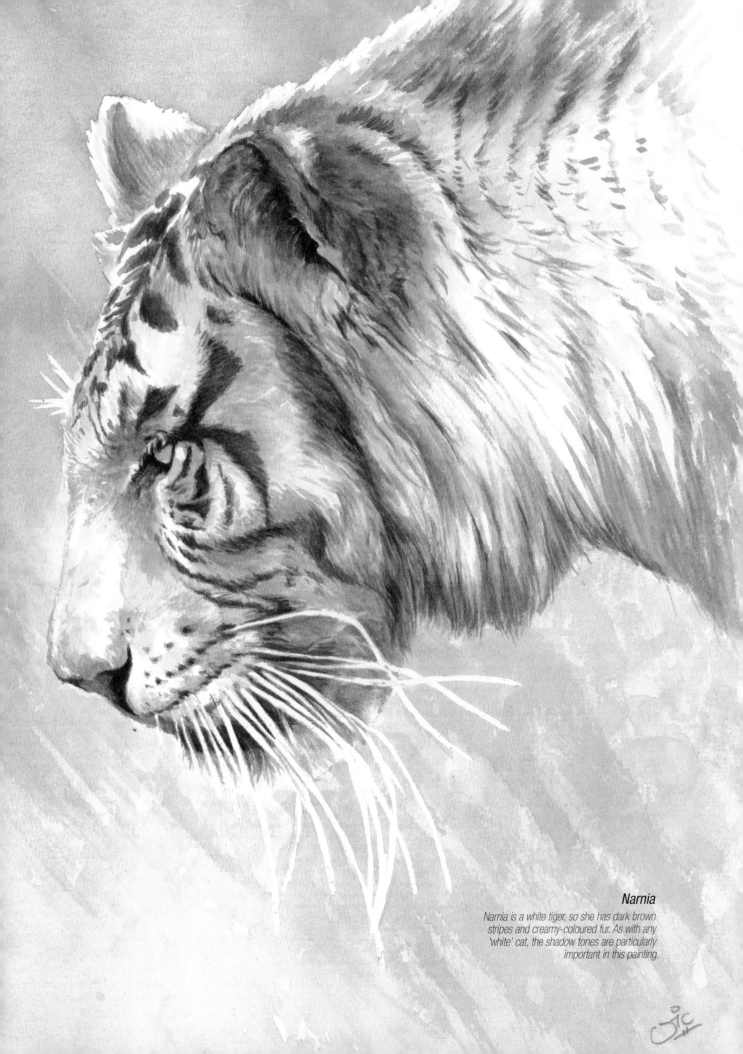

Narnia

Narnia is a white tiger, so she has dark brown stripes and creamy-coloured fur. As with any 'white' cat, the shadow tones are particularly important in this painting.

Glazing and feathering

Putting one transparent layer over another changes the colour subtly and still allows the light to shine through and reflect back through the paper, retaining the luminous effect of watercolours. These thin layers are called 'glazes'.

As always with watercolour, preparation is key. Use the time waiting for layers to dry by planning exactly where you want the next colour to go. Have a piece of scrap paper to hand to test the consistency of colours. The worst thing you can do is overwork it – if something isn't looking quite right at any stage, let it dry and lift it out with a damp brush afterwards. Trying to fix things while the paint dries will just result in a messy finish.

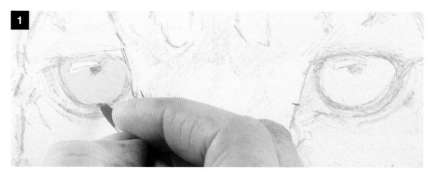

1 Set your board on the easel with your sketch secured in place with masking tape. Prepare the following colours fairly dilute (the thin consistency is important to successful glazing): cadmium yellow, sap green, cobalt blue; and Payne's gray at a medium strength. Working wet on dry, use a size 4 round watercolour brush to apply a wash of cadmium yellow over the whole eye, avoiding only the area of reflection.

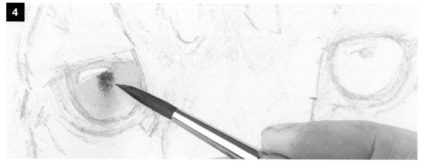

2 Ensure the first layer is completely dry before continuing, or you risk lifting and disturbing the pigment from the previous layer. Lay in a thin wash of sap green over the eye, avoiding the reflection and the highlight at the bottom. Over-brush as little as possible – lay in the colour with one or two strokes.

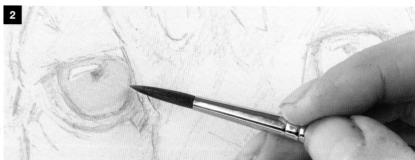

3 Once the sap green has dried, lay in a glaze of cobalt blue from the top of the eye down over the pupil, but no further. Again, avoid the reflection. Squeeze the brush between your fingers and use the damp tip to lightly soften the edge, a technique called 'feathering'.

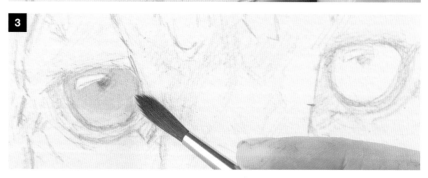

4 When the cobalt blue has dried to the point where it is merely damp, add the pupil using the slightly thicker Payne's gray. Adding thicker paint into a damp surface lets the paint bleed, but in a controlled fashion. The soft edges this gives the pupil helps to make it look like a natural part of the eye, rather than painted on later.

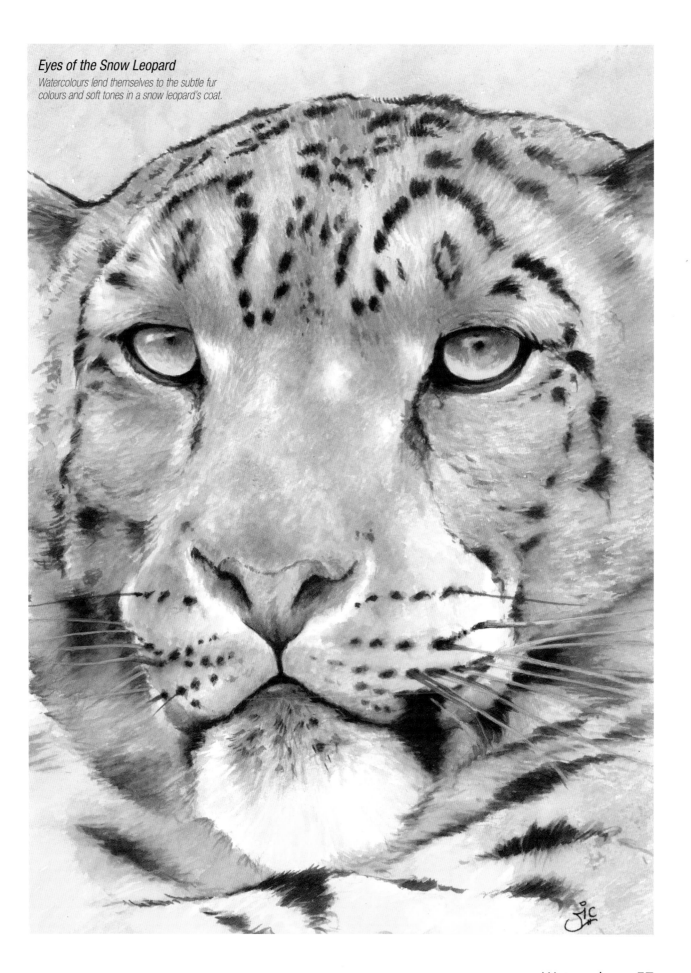

Eyes of the Snow Leopard
Watercolours lend themselves to the subtle fur colours and soft tones in a snow leopard's coat.

Phoebe – white domestic cat

The following step-by-step demonstration uses all of the techniques described earlier in one painting. The subject is Phoebe, one of our two white cats, who is easily distinguishable because she has different coloured eyes, one blue and one greenish-yellow.

There is, of course, more to painting white cats than simply masking off a white shape. There are shadows in the fur and pink skin showing through areas with less fur covering – around the eyes and nose, and inside the ears, for example.

Watercolours lend themselves well to painting this soft white fur; the less it is worked, the better. The focus can then be on the features, and those captivating eyes.

The finished painting

Reference

Phoebe, one of our white cats, makes an ideal subject for a watercolour painting. This is not only because of her soft white fur, but also due to her differently coloured eyes which add further interest to the finished painting.

 To the right can be seen the original reference photograph of Phoebe that I will use for this demonstration.

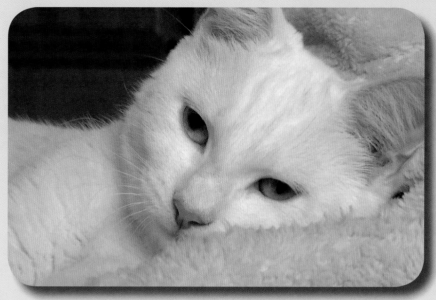

The reference photograph used for this painting.

Initial sketches

Before deciding on this particular pose, I sketched a couple of others, playing around with composition and cropping. The two sketches below were made to try to capture Phoebe in different poses, one alert to a sound and the other looking more focussed at something or someone. In the end, I decided on the resting pose, as Phoebe spends more time sleeping than any of our other cats.

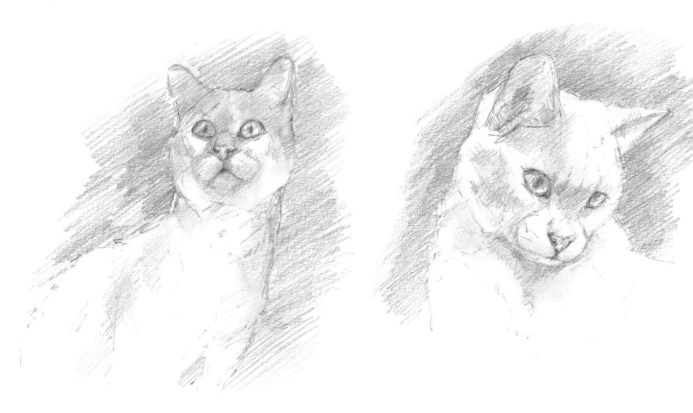

Painting

Preparatory sketch

1 Draw your sketch on to the watercolour paper using a 2B pencil, then secure it to the board on all four sides using masking tape. The paper is quite heavyweight, and so will not cockle when wet, but it is important to secure the paper all round to prevent it bowing as you work. The masking tape will also leave a nice clean border to your painting when you remove it at the end. Place the board on the easel.

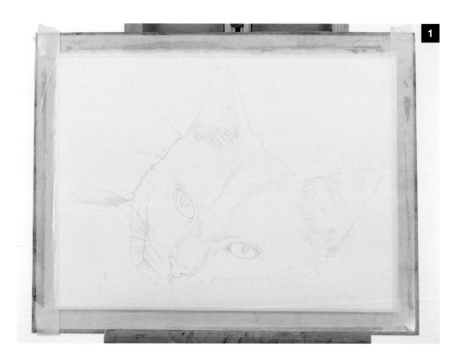

2 Apply masking fluid to any hairs that protrude into the background area, as well as the long hairs in the ears, the whiskers and the upper eyelids as shown. Allow the masking fluid to dry before continuing.

✿ Paws for thought

I have not masked the reflection in the eyes, as masking fluid gives a very hard edge to the shape when removed. To get a softer, more fluid feel to the reflection, it is better to reserve the space by simply avoiding the area when applying paint.

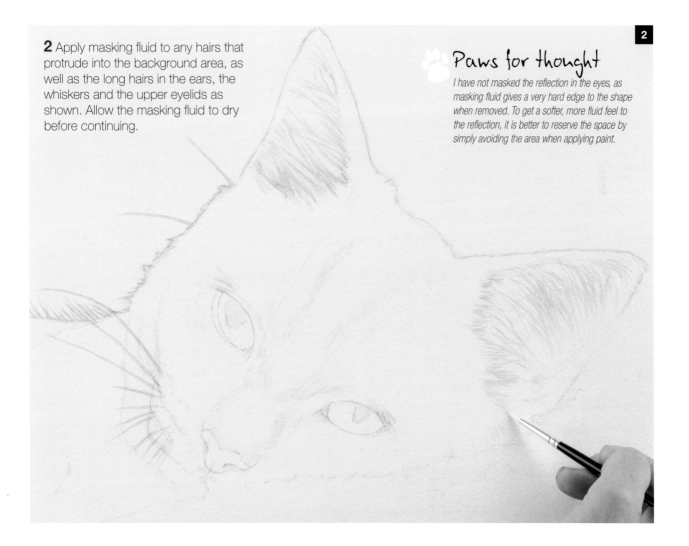

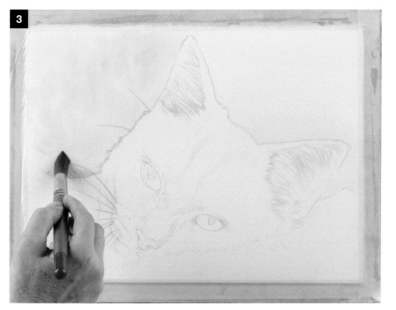

Creating the background

3 Prepare fairly large amounts of cobalt blue and rose madder, diluting them to roughly equal parts paint and water. Use a 12mm (½in) brush to wet the whole background evenly with clean water. Work up to the edge of the cat, using the blade and corner of the brush to get into tight spaces. You can work right over the masked-out whiskers. There is no need to rush this stage, but do make sure the whole background is glistening wet before you continue. If any drips run over Phoebe herself, dab them away with kitchen paper. Starting at the upper left, use the size 20 round brush to dab on some of the cobalt blue to create a soft, random effect.

4 Still working on the left-hand side, dab on some further cobalt blue touches. Do not try to add definition to the shapes – let the water take control.

5 Working quickly, dab in some rose madder in the same way. As the area starts to dry, this will create a subtle variegated effect to the background.

6 Repeat the previous steps over the rest of the background. Before you begin, check the paper is still wet – re-wet it if necessary before you begin to add the cobalt blue and rose madder. Allow the background to dry completely before continuing.

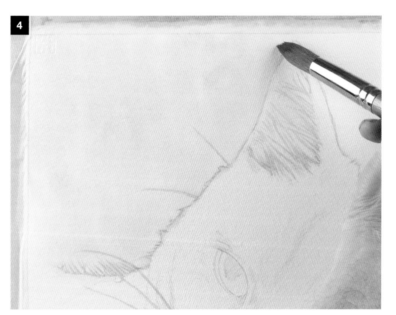

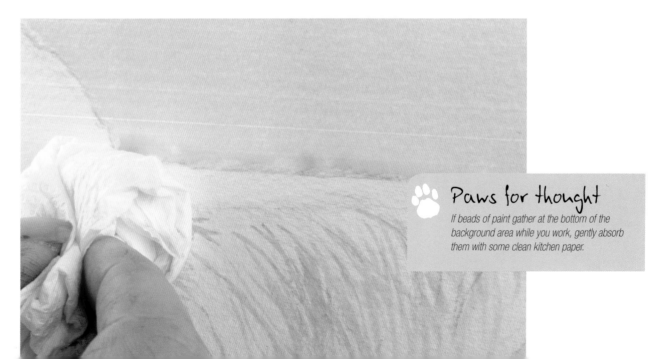

🐾 *Paws for thought*

If beads of paint gather at the bottom of the background area while you work, gently absorb them with some clean kitchen paper.

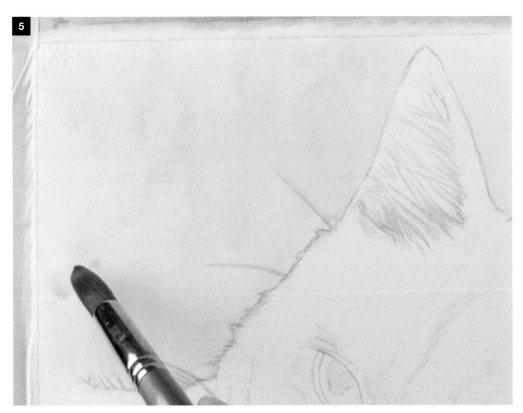

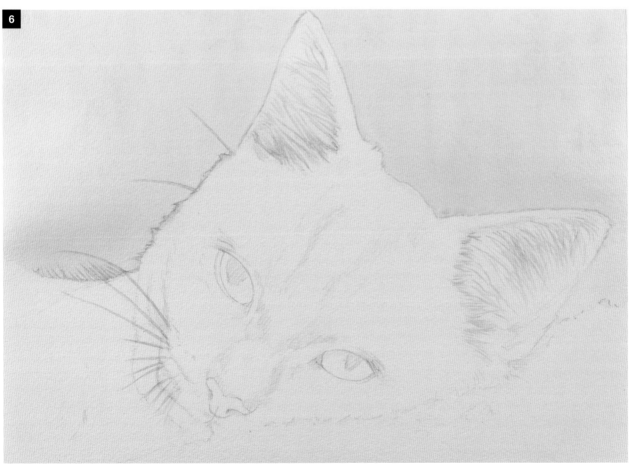

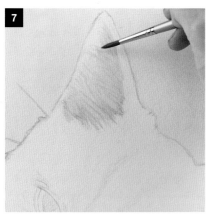

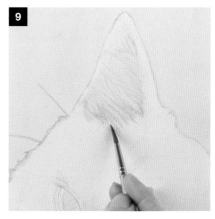

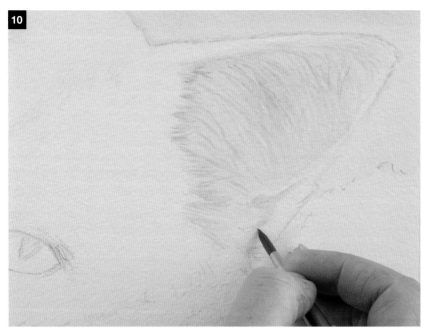

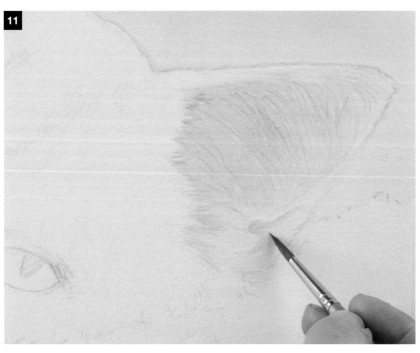

Painting the features

7 Switch to a size 4 round brush and lay in a glaze of rose madder into the upper ear.

8 While the paint remains wet, squeeze your brush and feather the left-hand edge away.

9 Add a few short strokes of rose madder at the bottom, where the ear meets the head, making them follow the direction of the hairs.

10 Paint the right-hand ear with the same brush and colour, softening the edges and using the rose madder to create the flap of skin at the base of the ear.

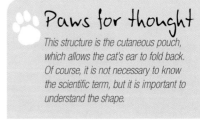

Paws for thought

This structure is the cutaneous pouch, which allows the cat's ear to fold back. Of course, it is not necessary to know the scientific term, but it is important to understand the shape.

11 Allow both ears to dry, then glaze the inside of each ear at the base with another layer of rose madder. This deepens the tone and reinforces the concave shape of the ear. Work gently, do not over-brush, and feather out the edges with a damp brush. Strengthen the ear shaping with the same glaze.

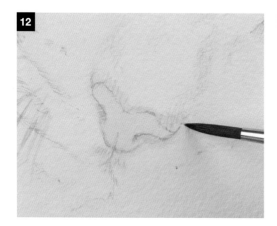

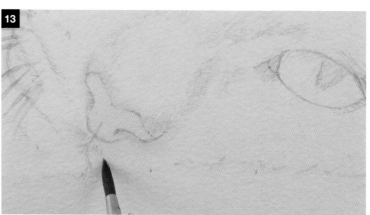

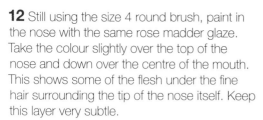

12 Still using the size 4 round brush, paint in the nose with the same rose madder glaze. Take the colour slightly over the top of the nose and down over the centre of the mouth. This shows some of the flesh under the fine hair surrounding the tip of the nose itself. Keep this layer very subtle.

13 Squeeze the brush and feather the colour away into the surrounding area.

14 Once dry, strengthen the colour and create shaping in the lower part of the tip of the nose with a second glaze of the rose madder.

15 Squeeze the brush and feather the colour into the surrounding area. You can use the tip of the brush to add a little texture by lightly stippling the area. The paint remaining on the brush will deposit in very subtle, soft spots.

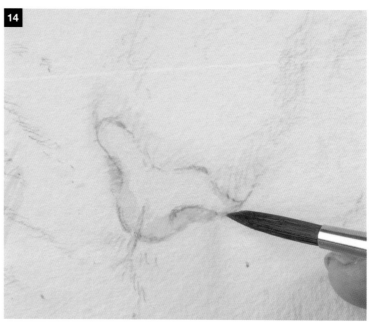

16 Paint both lower eyelids round to the tear ducts using rose madder and soften the edges a little with feathering.

17 Use a clean size 4 round brush to wet the eye on the left (Phoebe's right, blue eye) and drop in dilute cobalt blue. Allow to dry completely before continuing. Cobalt blue granulates slightly, which means that the particles of colour will gather in the recesses of the paper. This will give a slightly speckled effect to the finished eye.

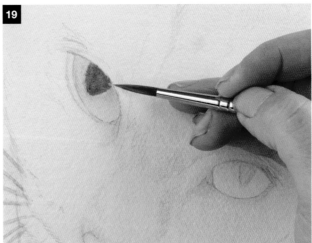

18 Once dry, lay in a second glaze of dilute cobalt blue on the eye, feathering it out to leave a crescent-shaped highlight at the bottom as shown.

19 Lay in a third glaze down to and around the pupil. Before it dries completely, touch in the pupil using fairly strong Payne's gray, so that it softens out a little to look more naturalistic. Observe the reference material carefully – you will notice the pupil of Phoebe's blue eye is slightly larger than that of her green eye.

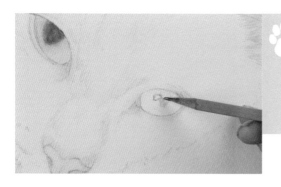

🐾 *Paws for thought*

Before step 20, I decided to mark out a sharper reflection on Phoebe's smooth green eye using a 2B pencil – it is not in the original photograph, but will emphasise the striking contrast between her eyes. This is not essential, so feel free to omit this addition.

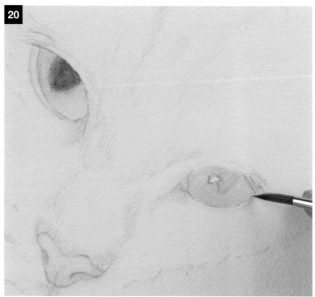

20 Use the size 4 round brush to add a cadmium yellow glaze into Phoebe's green eye as a base layer, avoiding the reflection area.

21 Once dry, lay in a glaze of sap green, leaving a crescent-shaped highlight at the bottom and avoiding the reflection as before.

22 Soften the edge of the green paint to avoid a hard line, then add the pupil with Payne's gray when the paint has not quite dried.

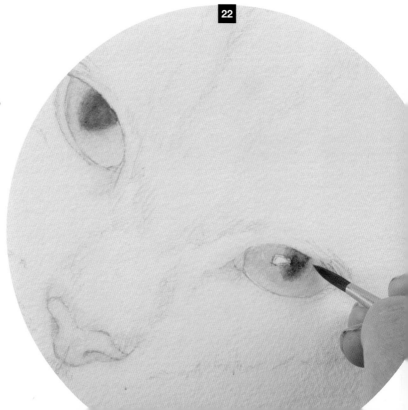

Developing the fur

23 Prepare a substantial amount of Payne's gray, diluting it to a watery consistency. This will be used to create very delicate shadows in the fur. Start with the texture around and between the eyes, using a size 4 brush to apply the paint and feathering it out. Use fine strokes, varying between the side and tip of the brush as appropriate for the size of mark you wish to make.

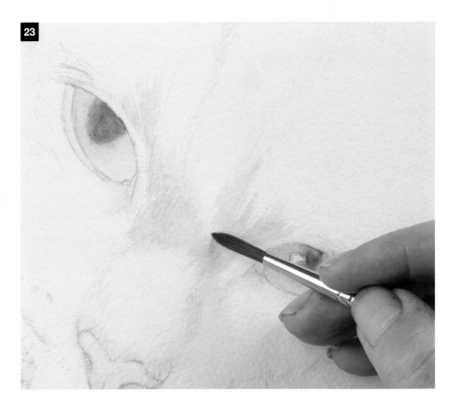

24 Continue to add light touches to pick out the texture of the fur on the forehead, softening the colour with feathering where appropriate. There is no need to soften every stroke – some distinct marks help to create the illusion of the silky individual hairs.

🐾 *Paws for thought*

The important things to bear in mind for these steps are the direction of the fur, and getting the tone correct. Err on the side of caution when preparing the Payne's gray. Remember that you can always lay another glazing layer over too-light areas, but it is much harder to fix marks that are too strong and dark.

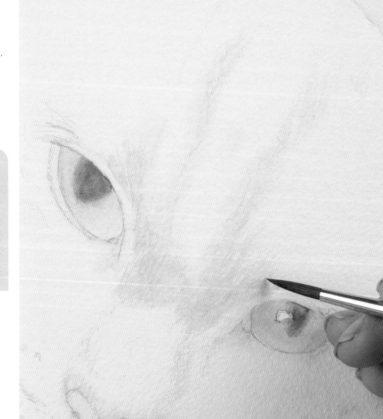

25 Continue to build up the shading and texture across the rest of Phoebe's head in the same way. There is a surprisingly large amount of grey shading visible on a white cat, so do not be too timid or hesitant – the visible pink flesh and cool grey help to frame and highlight the clean paper, and they provide important though subtle contrasts. As the paint dries, you can reinforce the tone around the eyes with additional glazes of dilute Payne's gray.

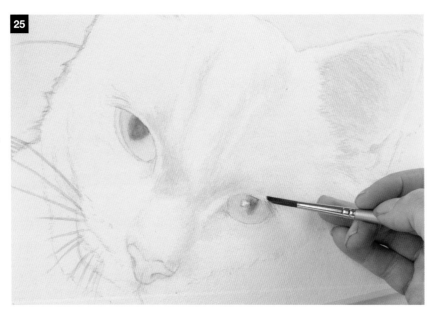

26 Add shading down the cat's neck and body in the same way. Keep these marks even more subtle, so the contrast is greater on the head than the body.

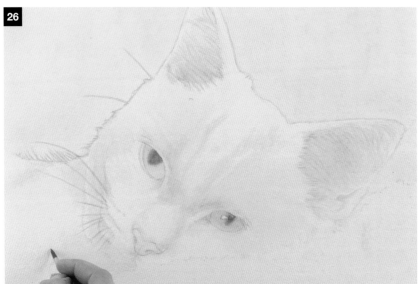

27 Once dry, go back and develop some tone and texture in the grey areas with additional glazed layers of shading.

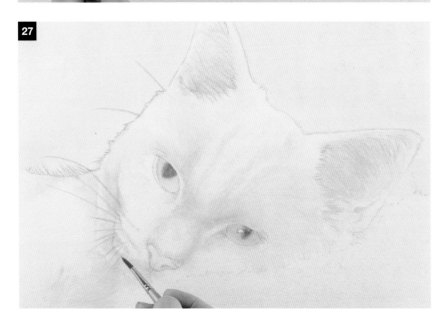

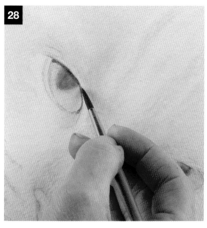

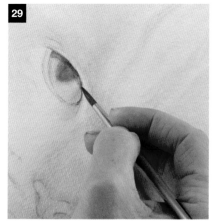

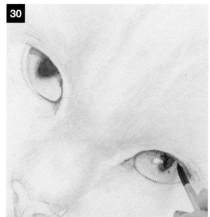

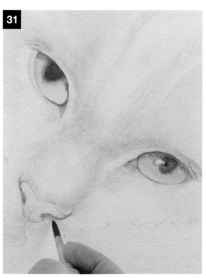

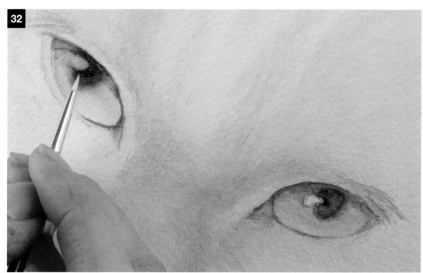

Finishing touches

28 Prepare a stronger – but not full strength – mix of Payne's gray and paint in the upper rim of the blue eye using the tip of the size 4 round brush.

29 Soften the colour away with a damp brush, and draw the colour into the pupil.

30 Paint the rim of the lower lid, feathering the colour away into the tear duct, then paint the green eye in the same way.

31 Use the Payne's gray mix to add some very fine lines to separate the eyelashes a little, applying the paint with the tip of the size 4 round brush. Do the same to sharpen the nostrils, adding definition with very fine lines. Paint the fine furrow on the nose and feather the colour out towards the mouth, to give the impression of very fine hairs here.

32 Wet the synthetic masking fluid brush and use it to lift out a soft highlight from Phoebe's blue eye. Watercolour paint is not permanent, so if re-wetted, the pigment can be lifted out if you agitate it slightly. When lifting out, clean the brush after every stroke or two, to avoid dirtying the area with paint you have lifted off.

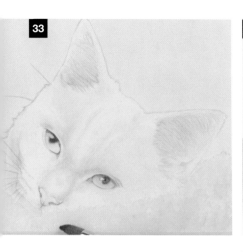

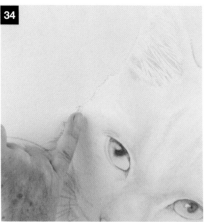

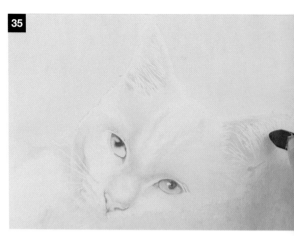

33 Use the size 20 round brush to add some random dabs of the dilute Payne's gray to the blanket, in the same way as you added the background at the very start.

34 Allow the painting to dry completely, then gently rub away the masking fluid using a clean dry finger. Work gradually and carefully – a little patience now can help prevent accidentally tearing or creasing the surface.

35 Continue removing the masking fluid until the whole painting is clear, then use a dust-free eraser to gently rub away any intrusive or extraneous pencil marks. There is no need to be obsessive – some light pencil marks can be left as part of the composition.

36 To finish, carefully remove the masking tape, to reveal crisp edges. Work bit by bit to help avoid the risk of tearing the surface of the paper away.

37 Make any adjustments you wish to finish – I have added some additional contrast with some more dabs of Payne's gray on the blanket.

The finished painting can be seen on pages 58–59.

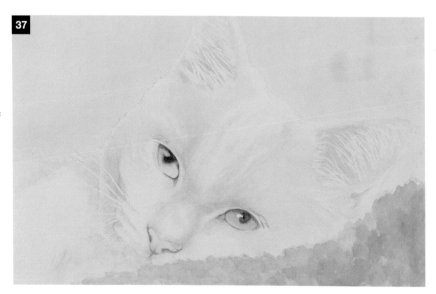

Acrylics

Acrylic paint is a relatively recent addition to painting media. The pigment is held in a synthetic polymer binder, unlike the oil used in oil paints or the water-soluble gum arabic in watercolour, and this makes acrylics hard-wearing and flexible when dry.

 The great strength of acrylics is their versatility, as they can be used to paint in different styles. The fast drying time and permanence of acrylics can prove a challenge, but the medium is becoming more and more popular in wildlife painting, and is well worth exploring for your cat art.

Leon

As a black and white tuxedo cat, Leon is well suited to being painted with white acrylic on a support covered with black gesso. This technique is all about painting the white fur, eyes, whiskers and soft highlights in Leon's black fur.

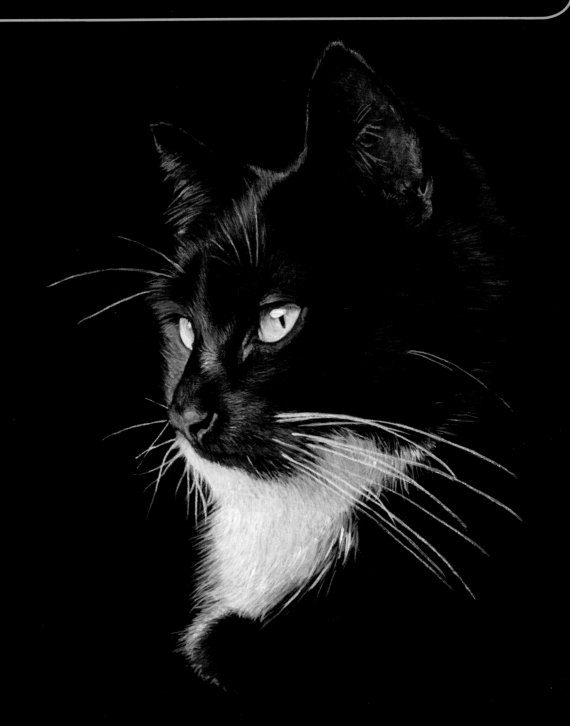

Materials for acrylic painting

Acrylic paint Students' quality paint which almost runs out of the tube as you squeeze it will be perfectly adequate for most of your fine detailed paintings.

Brushes I use semi-synthetic brushes with a good firm spring in the hairs. Brushes that are somewhere between a soft watercolour brush and hard bristle brush are ideal for acrylics. I use a size 9 hoghair flat, size 2 synthetic mix filbert, size 6 acrylic and oil round, size 8 acrylic and oil flat, size 4 round sable.

Surface Acrylic paper is a great alternative to canvas board. It is available in blocks of ten sheets. I use a 450gsm (210lb) acid-free, age-resistant acrylic paper.

Water pot As with watercolour painting, I recommend a transparent water pot – glass or plastic – as this makes it easier to see when your water requires changing.

Tap water Most tap water is fine for diluting acrylics.

Sealable palette A plastic, lidded takeaway carton makes an ideal acrylic palette for use over several days. Cover your palette if you are leaving it overnight, otherwise any prepared paint will dry out and become unusable.

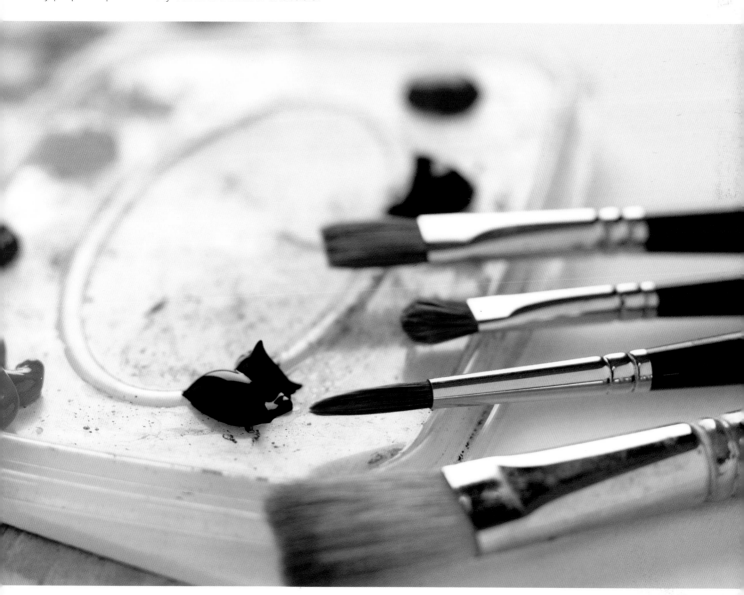

Acrylic techniques

Acrylic paints are quite versatile, and can be used in various ways. If you dilute them a lot, you can use them with watercolour techniques (see pages 50–57), while if you use them neat, you can use oil techniques. Using heavy body acrylics (especially thick acrylic paint) opens the door to painting in a thick *impasto* style.

Preparing acrylic paint

The way that I use acrylic to paint cats is almost the same as with watercolour; diluting with varying amounts of water to achieve different thicknesses of paint to keep the pigment flowing over the paper.

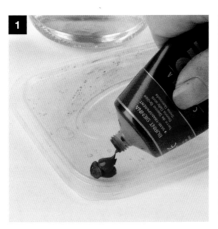

1 Squeeze a fair amount of paint from the tube onto one of the corners of your palette.

2 Wet the brush with which you will be painting, dab it into the paint, then draw out the paint. By adding more water, you can create dilute washes, or you can use the paint almost neat for textural effects.

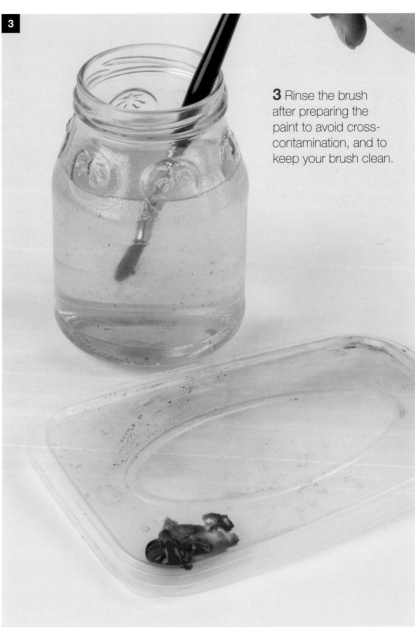

3 Rinse the brush after preparing the paint to avoid cross-contamination, and to keep your brush clean.

Applying acrylic paint

Acrylics can be applied as thin glazes, or directly from the tube for thicker layers. Once dry, you can overpaint to build up strength of colour without disturbing existing layers.

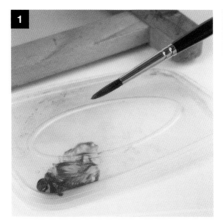

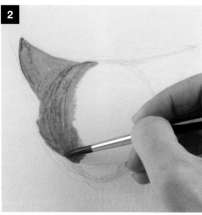

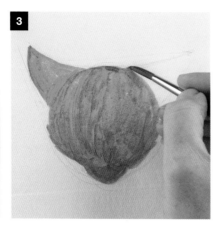

1 To load the brush, dip the tip into the prepared paint at an angle, then roll it slightly in the paint and lift away.

2 Use the body of the brush to fill in large areas quickly. Reload the brush as you work, and rewet the brush occasionally to prevent the paint drying inside the belly of the brush.

3 To achieve sharp lines, hold the brush at a slight angle as you apply the paint to the paper so the bristles are kept together in a point.

4 Build up the effect with repeated applications; though do make sure that the previous layer is completely dry before proceeding. Used more thickly than watercolour, as shown on the left-hand side of the face in the picture, repeated layers of acrylic paint can quickly create great textural effects. Used in thinner glazes, a flatter, more even and bolder finish can be achieved with acrylic than with watercolour.

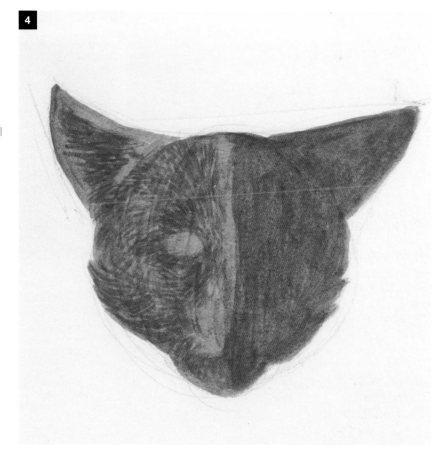

Glazing over white

Acrylic paint has great covering power if it is not diluted too heavily, and can be used to great effect over black surfaces, such as this paper, which has been prepared with a layer of black gesso.

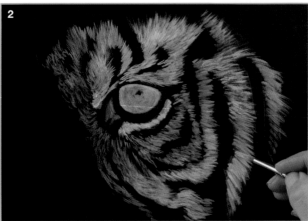

1 Paint the white areas using titanium white and a size 6 round brush. Use the paint almost undiluted, and apply it using the end of the brush. This will create a texture that is ideal for fur, and will help to create the illusion of shadows on the fur at the later glazing stage. Do not panic if you paint over something that should be black, as you can paint over it later.

2 Pay attention to the length and direction of the hairs at this stage, because these strokes will create the fur texture of the final image. In addition, look at the tone of the fur on your reference image. Deeper fur can be applied with a single stroke, to give a faint result, while lighter areas of fur should be brought out through repeated strokes of white acrylic until you achieve the correct tone.

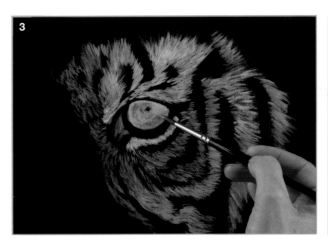

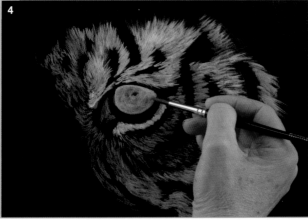

3 Once the paint has dried, prepare some diluted paint and use the same brush to glaze coloured paint over the surface. You can work quite quickly, as the tones and texture have already been established. Err on the side of caution and start with a paler tone than you think is correct – it's much easier to overlay a second glaze to strengthen the colour than correct an over-strong layer.

4 Repeated glazes can be used to tint and alter the hue. Here I have used a faint green glaze over part of the yellow eye.

Paws for thought

When working over a black undercoat as in this example, use a white watercolour pencil to make your initial sketch.

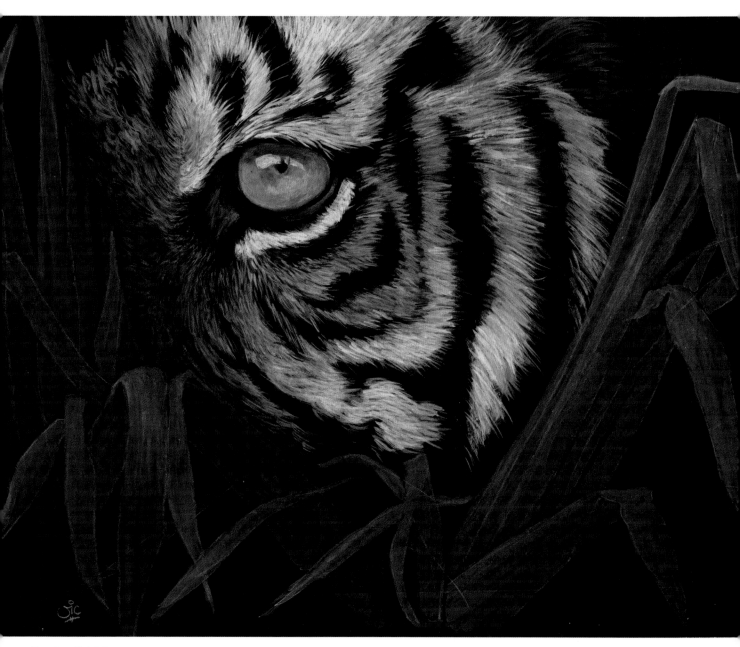

Burning Bright

Acrylics on black paper. Foreground foliage has been added to create an atmospheric setting. The leaves are painted in the same way as the fur: with glazes of green over a white underpainting.

Overpainting

One advantage of acrylic paint's covering power is that light colours can be freely added over darker colours, unlike other media. On the other hand, it can be harder to achieve the smoothness of a flat watercolour wash with acrylics. Overlaying a glaze of dilute acrylic paint on top of an existing layer can help to blend any rougher transitions together and enrich the colour.

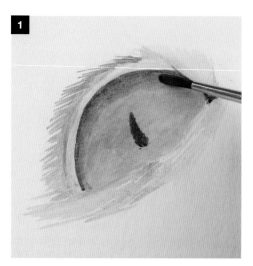

1 When painting areas such as this highly reflective eye, paint over the whole area with a glaze (see page 76) to avoid awkward transitions and create a smooth effect.

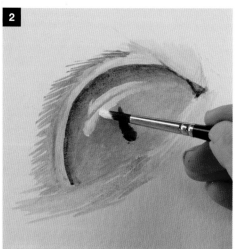

2 Once completely dry, you can use the tip of the brush to apply light paint – titanium white in this example – directly over the underlying colour.

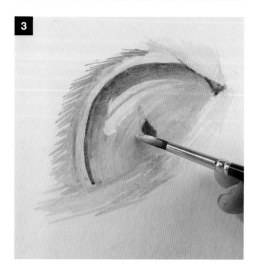

3 Even when used fairly watered-down for a translucent glazed highlight, the white will effectively cover the strong black of the pupil. Used neat, the light paint will completely cover and obscure the underlying colour.

Oscar Wildecat

In addition to the unusual angle and cropping of Oscar's portrait, note the curved reflection in the eye, following the curve of the cornea. The paint is applied in a series of glazes over a grey underpainting, giving a softness which can otherwise be quite difficult with acrylics.

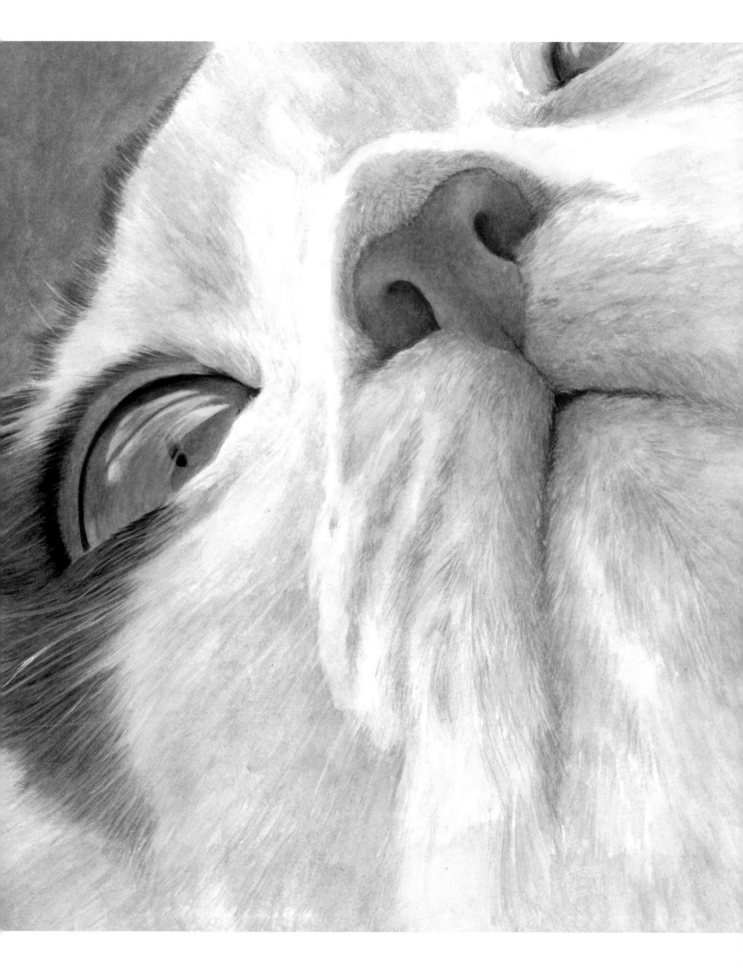

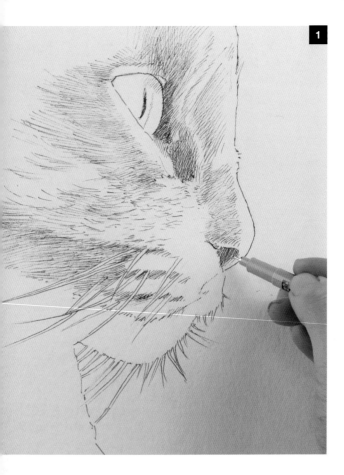

Using acrylic like a watercolour

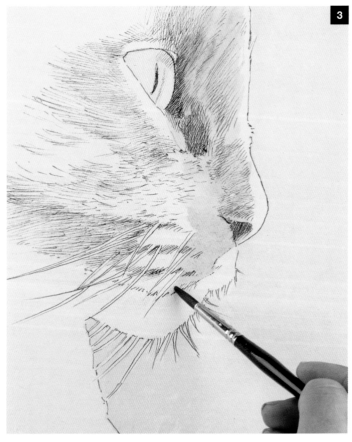

Acrylic paint is very versatile, and can be used in a similar way to watercolours. Here I am using it to tint a pen drawing, in order to create a pen-and-wash style illustrative effect. Acrylic lends itself to this illustrative style for multiple layers because it is permanent, and there is less risk of adjacent areas bleeding into each other than with watercolour.

1 Using a waterproof permanent black 0.35mm pen, make a pen sketch.

2 Prepare a very dilute mix of acrylic, and apply the paint using the brush exactly like watercolour. The main difference with acrylic washes used in this way is that they are permanent, unlike watercolour, which will lift if worked back over.

3 Continue applying the colours to create a subtle finish like watercolour – acrylics do not have to be bold – before adding further details and darker tones with the ink pen.

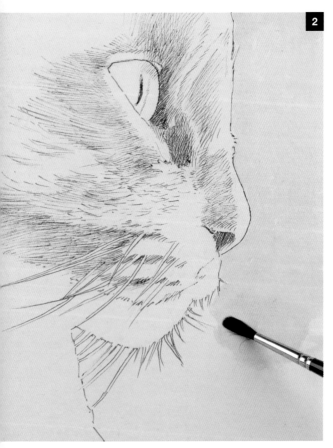

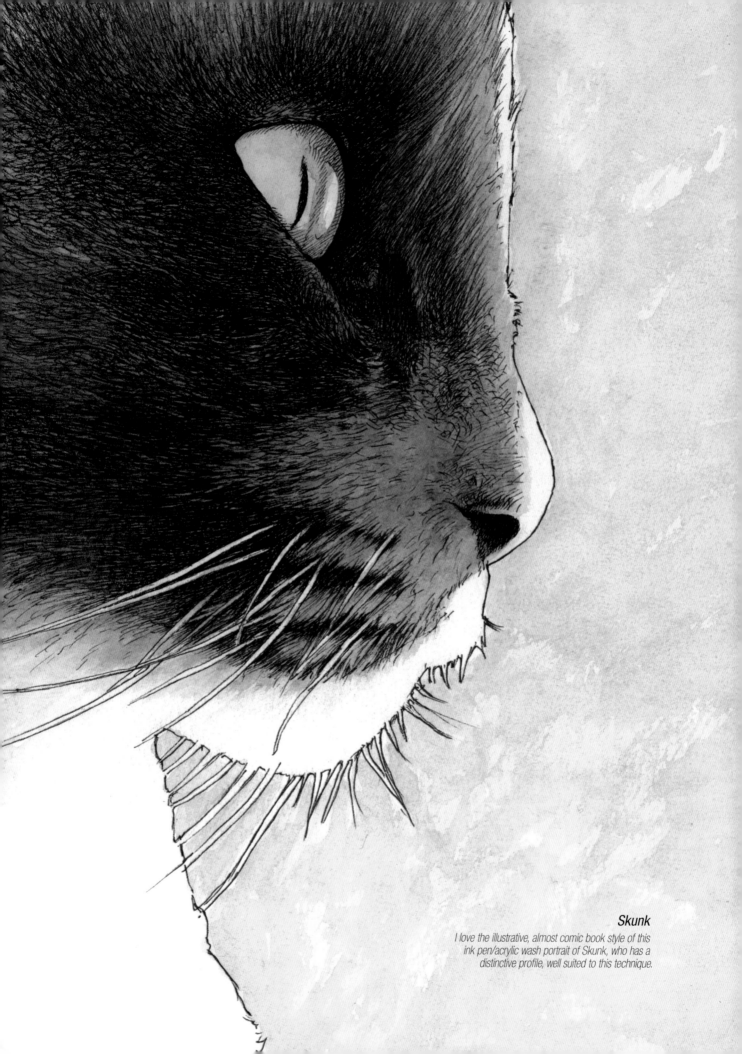

Skunk

I love the illustrative, almost comic book style of this
ink pen/acrylic wash portrait of Skunk, who has a
distinctive profile, well suited to this technique.

Themba – white lion

In order to paint Themba, a handsome white lion from the Wildlife Heritage Foundation, we focus on one acrylic technique: that of glazing transparent layers of colour over a fairly detailed tonal underpainting.

This will result in a softly textured painting, with a finished effect similar to a watercolour painting, but with the colours and tones being a little stronger. The more layers you glaze, the deeper the colours will appear.

You will need

2B pencil

450gsm (210lb) acrylic paper

Masking tape, board and easel

Dust-free eraser

Acrylic paints: chromium oxide green, burnt umber, yellow ochre, ivory black, unbleached titanium white

Black gesso

Size 6 round oil and acrylic brush, size 2 filbert oil and acrylic brush, size 4 round watercolour brush

 Paws for thought

When visiting zoos and wildlife centres for reference, do not neglect your backgrounds – such places often have exotic foliage or jungle plants, which can add a great deal of interest to your cat artworks.

The finished painting

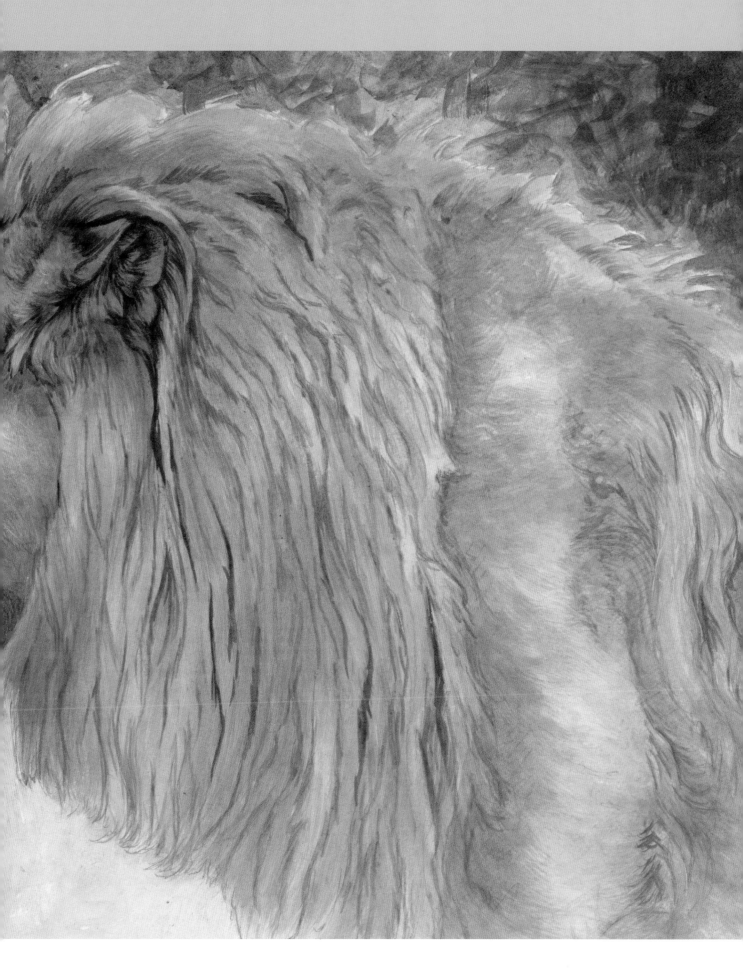

Reference

This photograph of Themba shows him as a juvenile; his full mane yet to develop. Nevertheless, his regal expression is already evident, albeit as a prince rather than a king.

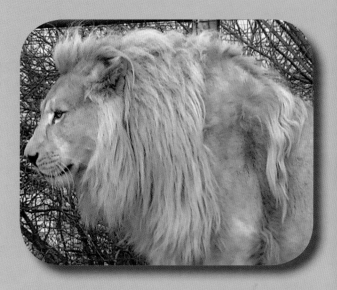

Initial sketches

In the initial sketches I made of Themba, shown below, I tried to focus on his princely expression, experimenting with different angles from a three-quarter view to his upturned head in profile. In the end, I decided that the downward-facing version shown in the reference photograph above better evokes the feeling of a young pretender overlooking his potential territory.

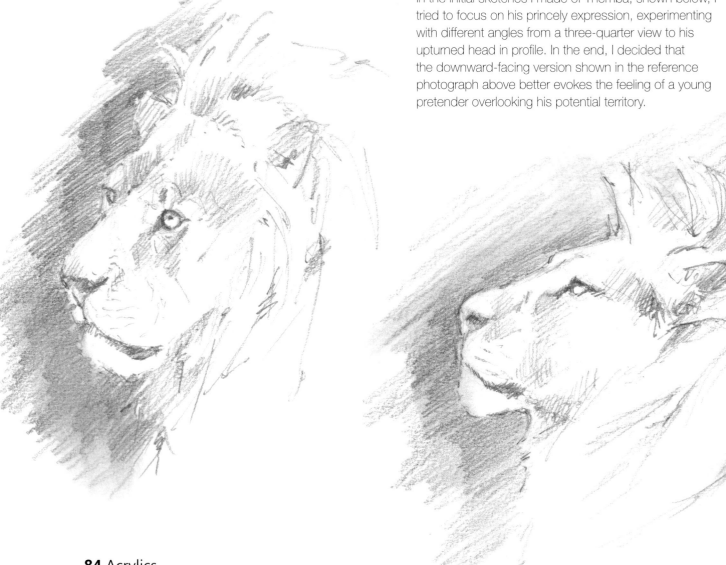

Painting

Preparatory sketch

1 Use a 2B pencil to draw your sketch on to the acrylic paper. Mount the sketch on the board using masking tape, then place the board on the easel. It is important to create an accurate sketch before you begin; it will make painting the piece much easier!

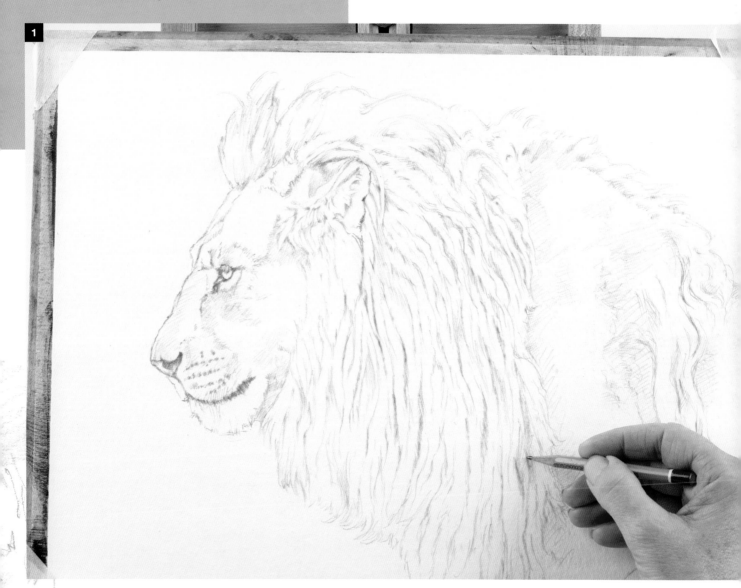

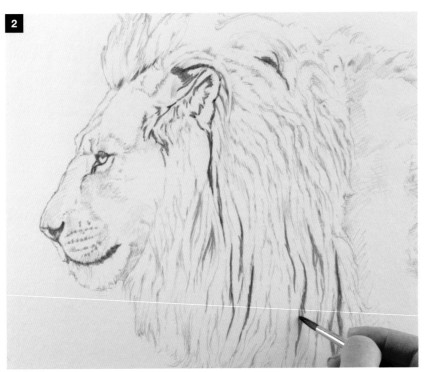

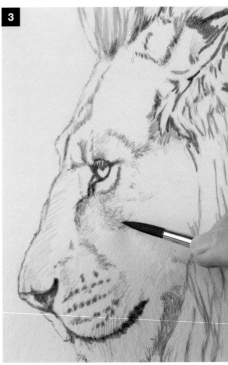

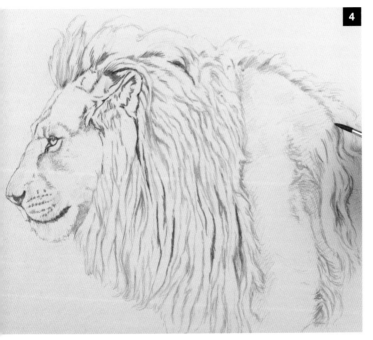

Creating tone

2 Prepare a mix of black gesso diluted to a mid grey (this is prepared in exactly the same way as acrylic paint, which is described on page 74) then use the size 6 round oil and acrylic brush to apply the mix to the darker areas. Start from the top and work down the painting in order to avoid putting your hand in the gesso before it dries. We are establishing the main shapes using a mid-grey instead of a black because we will later add layers of glazed colour over the top. The mid-grey will strengthen, but not become overdominant as a black would. Work carefully and use the end of the brush to apply the paint in a controlled way.

3 Dilute the gesso a little further and begin to establish the softer shadows in the same way. Begin to suggest texture in the fine fur of the face using tiny touches of the very tip of the brush. Hold the brush at a shallow angle, so that the point does not split.

4 Continue to establish the softer shadows across the rest of the head and the mane. These early stages produce a fixed permanent underpainting that will create the tone of the work as you add glazes of colour, as well as delineate the form of the lion. The more you do at this early point, the easier you will find the later stages.

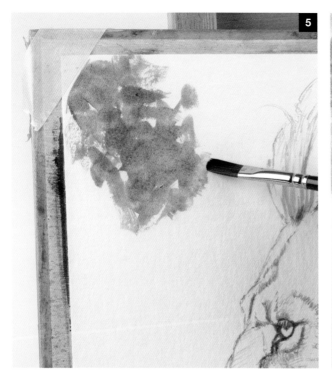

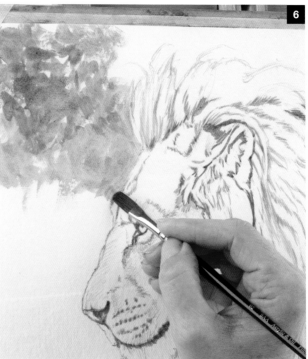

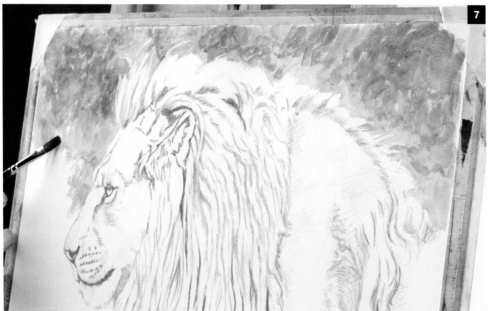

5 Switch to the size 2 filbert oil and acrylic brush and begin to build up the background using the mid-grey mix. Use a variety of angles when applying fairly short brushstrokes to create texture and interest.

6 When you reach the outline of the lion, use the blade edge of the filbert to avoid going over the lines while retaining the free, loose feeling of the brushstrokes.

7 Work over the whole top of the background with the mid-grey. Work carefully, but not fussily, around the top of the mane, and leave some white areas and natural gaps as shown.

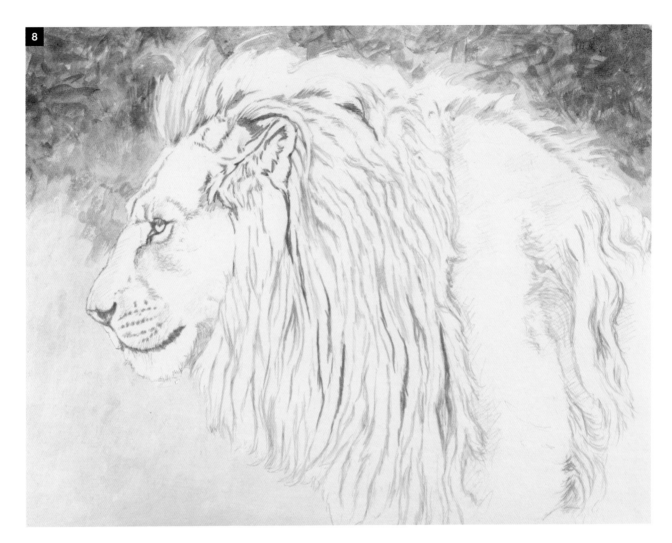

8 Deepen the tone in the corners with a second layer – you can add the loose suggestion of branches with brushstrokes if you wish, but do not be tempted to overcomplicate the background or you risk drawing the eye away from Themba himself. Dilute the mix and work the background down to the bottom of the page.

9 Still using the filbert brush, create a very dilute mix of black gesso and use it to add a unifying glaze over light areas. This glaze helps to 'kill' the white of the paper background, and to reduce the tonal contrast between the marks you have made and the previously bare areas. This glaze should be fairly smooth, so apply it quickly and loosely – while you do not want to create heavy texture, you equally do not want obvious brushstrokes in a single direction.

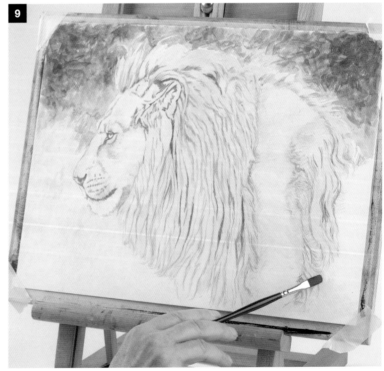

10 Allow the painting to dry thoroughly before continuing. Add a little paint to the mix to create a darker-toned mix, and use this to glaze over the midtoned areas such as the inside of the ears, the cheeks and general structure of the skull. Work in small areas at a time, and aim for soft edges. The filbert will help here as the curved corners will not make sharp marks. You can also quickly rinse your brush, squeeze out excess water and use the clean damp brush to blend away paint while it is wet.

 Paws for thought

I find the best way to identify areas of tone is to squint at your reference image until the detail is lost, leaving just vague tonal shapes.

11 Develop the mane with similar glazes, creating shape and form to the mane as a whole. Next, use the tip of the filbert brush to add short light brushstrokes on the shoulder to suggest the shorter, harder hairs of the fur here.

12 Continue to add these unifying glazes across the lion to link tonal areas and add shaping. This completes the tonal sketch. Having at least three tones – light, medium and dark – creates form that the colours will help to develop. As mentioned, more tonal contrast will result in a more effective result, so it is well worth spending a lot of time on these early parts of the painting.

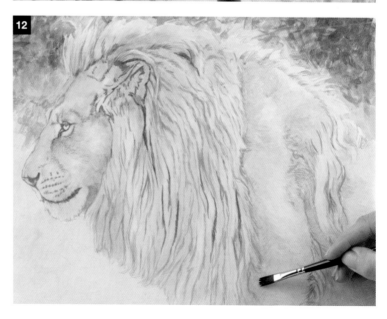

Adding colour

13 Prepare a thin glaze of chromium oxide green – something at the consistency of a watercolour wash – and use the filbert brush to apply this to the darkest part of the background. Use the same textural, loose marks used to build up the underpainting in order to further develop the texture. Start on the darkest part to make sure that the colour is visible. If it tints even the darkest part, it is just right, and will build up over the other tones well. If it doesn't show, add a little more paint to make a less dilute mix and try again. The crucial part is that the texture is still visible underneath the glaze.

14 Build up the remainder of the background with the same brush, technique and mix. Work carefully around the edge of the lion, using the blade of the filbert to your advantage as explained in steps 6 and 10.

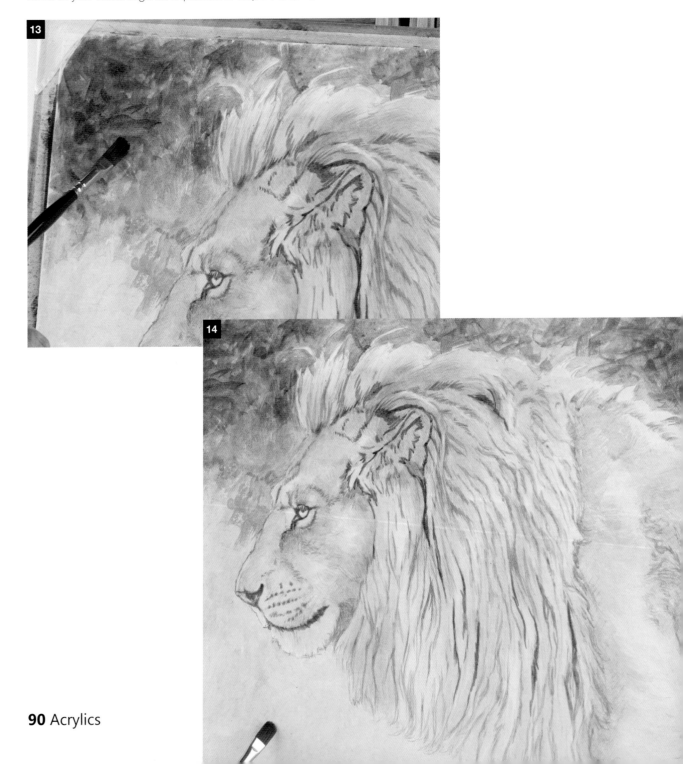

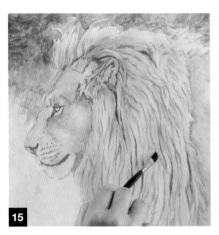

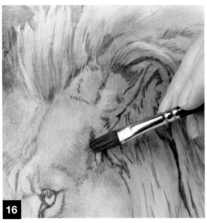

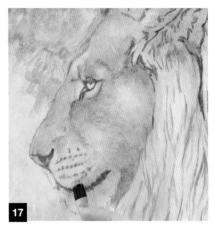

15 Prepare and lay in a dilute yellow ochre glaze across the whole lion (including the eye) using the filbert brush. Do not panic – this will look a little false at this point, but later detail requires this strong warm underlying colour. Work in small areas so you have time to soften the colour using a clean damp brush if necessary. Use brushstrokes that complement the area – shorter strokes on the face, longer strokes on the mane. This helps you get in the mindset of painting the appropriate shapes in areas, and remembering you are painting a lion, not a piece of paper.

16 Prepare a fairly dilute burnt umber mix. Look carefully at your reference photograph and identify the cool areas of shadow. Still using the filbert brush, start to glaze these areas with the burnt umber using light, feathery brushstrokes to reaffirm the direction of the fur.

17 Work over the whole face; this will begin to reinforce the texture of the fur you established earlier, and also soften the transition between the shadow and the midtones, creating a more realistic effect. The nose is in shadow, so use this glaze here, too.

18 Glaze the cool shadow over the rest of the lion to draw out the structure of Themba's underlying musculature.

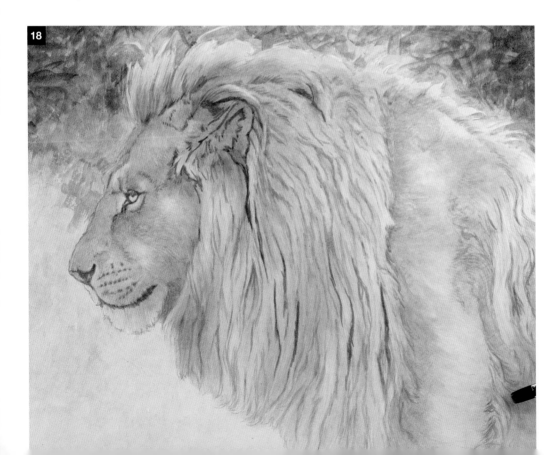

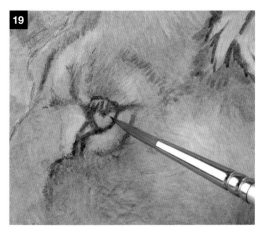

Details and finishing

19 Switch to the size 4 round watercolour brush and paint in Themba's eye using yellow ochre paint.

20 Still using the size 4 round watercolour brush, use slightly diluted ivory black to touch in finer details on areas such as the recesses of the ear. Prepare a small amount of paint at a time, and refresh it often to make sure you are working with good flowing paint, rather than rushing and trying to use drying paint. The increased contrast of these small black additions will draw the eye, so aim to bring the viewer's gaze towards the focal point by restricting these dark details to the facial area. Hold the brush near the tip for maximum control.

21 Use the very tip of the brush to add a soft shadow under the eyelid with a diluted ivory black (see inset), then pure ivory black for the eyes, nostrils, lips and a few fine dark hairs under the chin.

22 Use unbleached titanium and the size 6 oil and acrylic round brush to add secondary highlights. These off-white touches are added to soften areas and to help evoke and emphasise the shape and how the fur lies. Wet the brush, then squeeze out excess water, and dip and roll it lightly in the undiluted paint on your palette. Use fairly thick strokes to apply the paint to the areas of the mane in the light. You are painting clumps of the mane, not individual hairs. These secondary highlights also serve to soften some of the harsher tonal contrasts by overlaying areas.

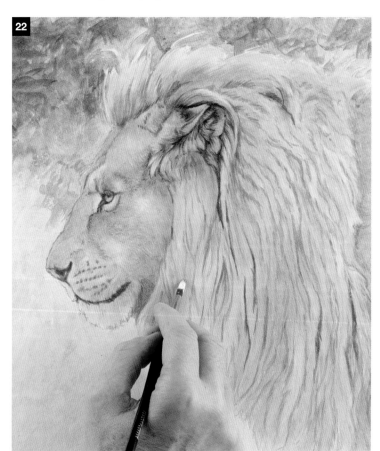

Paws for thought

Apply highlights sparingly. Pause often and consult your reference photograph to make sure that you are not swamping the tonal work with too many highlights.

23 Change to the size 4 round watercolour brush and add secondary highlights to the face. Apply the paint completely neat here (i.e. undiluted) but use very small and controlled strokes.

24 Use titanium white and the size 4 round watercolour brush to add the primary highlights, which are placed to draw the eye by creating points of maximum contrast. This creates impact, but it relies on you applying only sparing touches around the brow, eye and mouth.

25 Add whiskers using titanium white diluted to a creamy consistency. Whiskers are shorter and finer at the front, longer and thicker further back. Aim to make each whisker with one, or at most two, swift strokes.

The finished painting can be seen on pages 82–83.

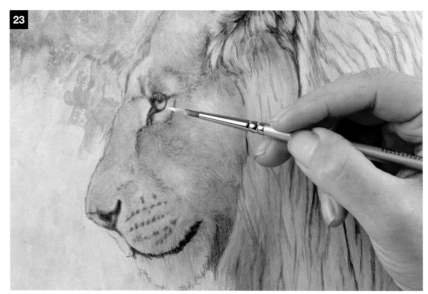

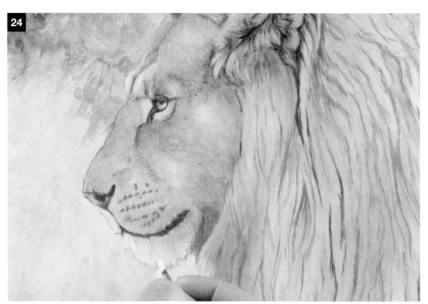

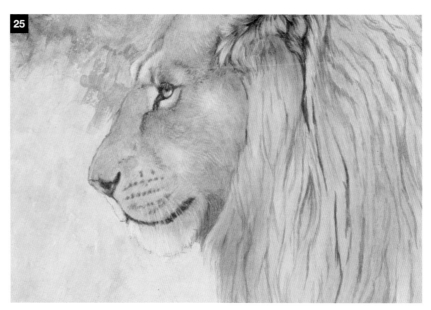

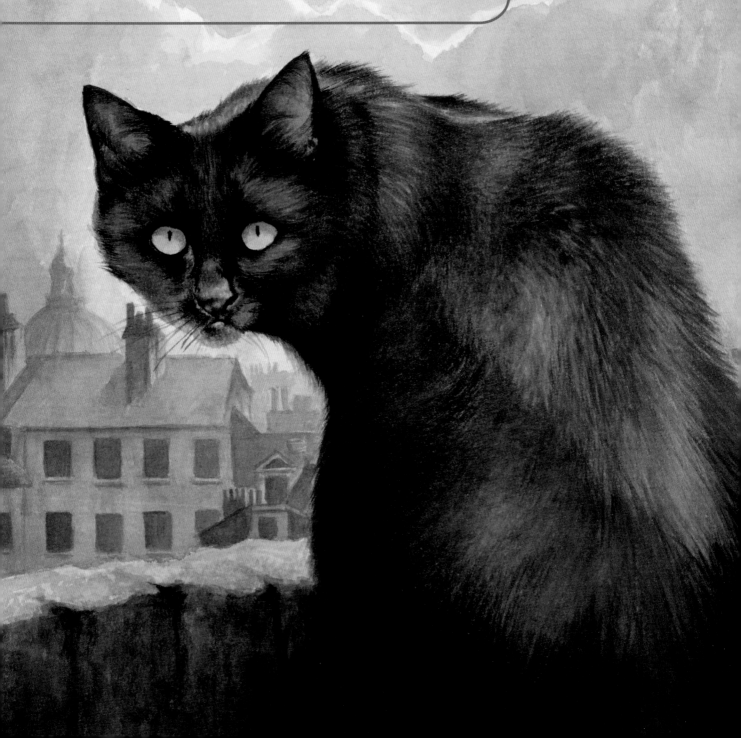

Indian ink

Traditionally used for writing and printing, in recent times Indian ink has been used for drawing, especially comic books and graphic novels.

 I find that using Indian ink with a brush, diluted as with watercolours, results in lovely soft tonal paintings, with subtle nuances. It is a perfect medium for painting cats of all kinds – not just black cats, as you will discover.

After Dark
Subtle grey tones in the city background contrast wonderfully well with the very dark, yet soft tones in Marley's fur in this depiction of what goes on while the city sleeps.

Materials for ink painting

Indian ink Indian ink is a black, permanent ink made from fine soot called 'lampblack' combined with a binding agent called shellac, which makes it very durable when dry. Avoid acrylic ink, as this is dye, rather than pigment based, and will fade over time.

Watercolour brushes The softer hairs of a good quality, sable or semi-synthetic watercolour brush work really well with Indian ink.

Water pot As for watercolour or acrylic paints, a transparent glass or plastic pot is best.

Deionised or distilled water Tap water contains fluoride and other chemicals which break down the shellac. Deionised water works just as well as distilled and can be purchased cheaply from garages.

Sealable palette A plastic takeaway container with a lid will keep the ink liquid for longer.

Kitchen paper This is used to clean your brushes.

Watercolour paper A slightly textured (Not surface) heavy paper of around 425gsm (210lb) will take a lot of water and stop the ink drying out too quickly on the surface.

Dust-free eraser This is ideal for erasing your pencil underdrawing, without leaving a lot of rubber 'crumbs'.

Ink techniques

There are two basic techniques for using Indian ink. Firstly, drawing using a pen nib. This creates strong lines, from very fine to wide strokes. Secondly, painting with a brush. This can create not only strong lines, but also very subtle, silvery grey tones, giving much greater depth in ink artwork. It is the painting technique that I will use in this section.

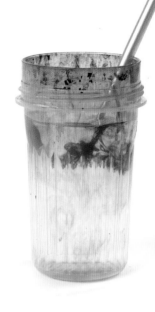

Preparing ink

When using Indian ink, preparation is vital. Pour the correct amount for the job at hand – too much and the excess will dry out and be wasted – and make sure you use the appropriate dilution for the depth of tone you need.

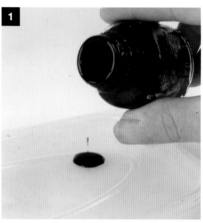

1 Pour a small amount of ink from the bottle directly on to the palette. Use a small amount because the binder (usually shellac) starts to dry on contact with the air – and in any case, a little goes a long way.

2 Dip a medium detail brush into distilled water, get it soaking wet, then lift a bead of water over to the palette. Use the wet brush to draw some ink into the bead of water and mix them together.

3 Depending on the amount of water you add, you can create different tones. Diluting the ink by adding more water creates lighter tints.

Paws for thought

Cover the palette if you go away for any length of time to keep the working time for the ink as long as possible.

Applying ink

Indian ink should be applied carefully, with pre-planning. Once dry, it cannot be removed.

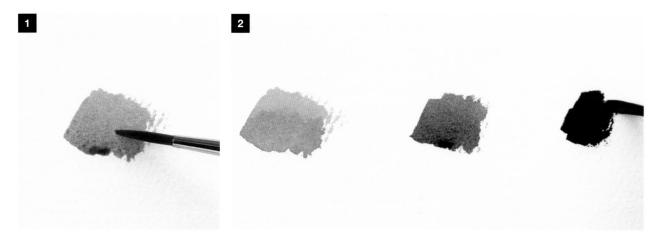

1 Ink can be applied to the paper using a watercolour brush, much like using watercolour paint wet on dry.

2 More water in the mix makes lighter-toned results (left of image), while more ink creates stronger, darker tones (right of image).

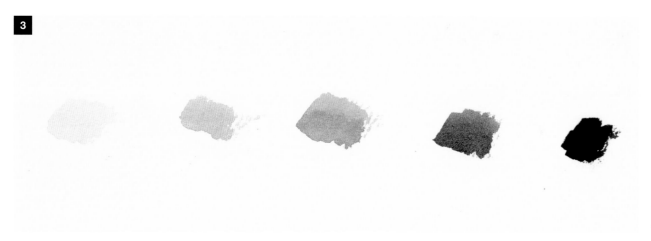

3 Pure ink is almost completely opaque (far right of image), and it can be diluted almost to nothing (far left of image).

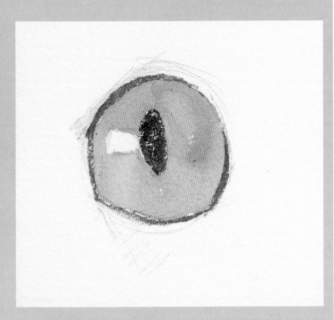

Poor use of ink

This image shows an eye painted using drying ink, tap water and an insufficiently loaded brush.

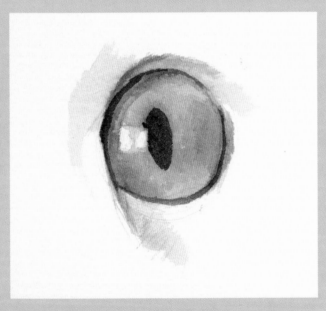

Good use of ink

This image shows an eye painted using fresh ink, distilled water, and a properly loaded brush.

Working with ink – troubleshooting and advice

Ink is relatively simple to use, but there are a few common pitfalls to avoid.

Use distilled water The dissolved minerals in tap water or mineral water affect the shellac binder and cause small particles to be drawn out. This causes streaking and cauliflower-like shapes to appear in the ink as it dries.

Use a properly loaded brush Not enough ink on the brush will create unsightly drag marks on the paper as the ink dries too quickly, and it becomes much harder to draw smooth curves with the brush.

Never re-use dried ink Unlike watercolour, inks cannot be properly rewetted. You will end up with small particles of dry ink in a suspension instead of a smooth solution.

🐾 *Paws for thought*

Use a piece of scrap paper to test your tones before you apply it to the finished painting. Make sure to use the same type of paper surface as your final painting.

Opposite:
Gladys and Ruby Roo
Gladys, one of our white cats, took on a maternal role with Roo, a tiny orphaned kitten. Indian ink manages to create an atmospheric painting, full of warmth, even in monochrome.

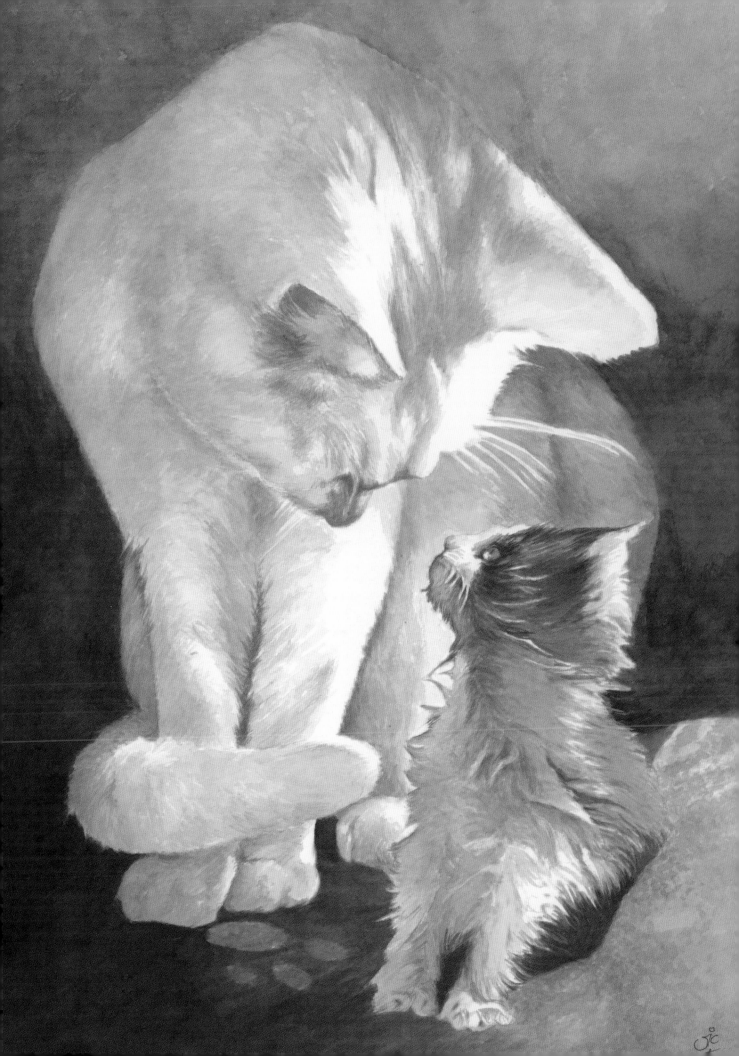

Creating markings with tone

If you are painting a cat with stripes or other markings, it is often a good idea to begin establishing the general shapes of these markings with a midtone. Sharper details and lighter-toned fur can be added later.

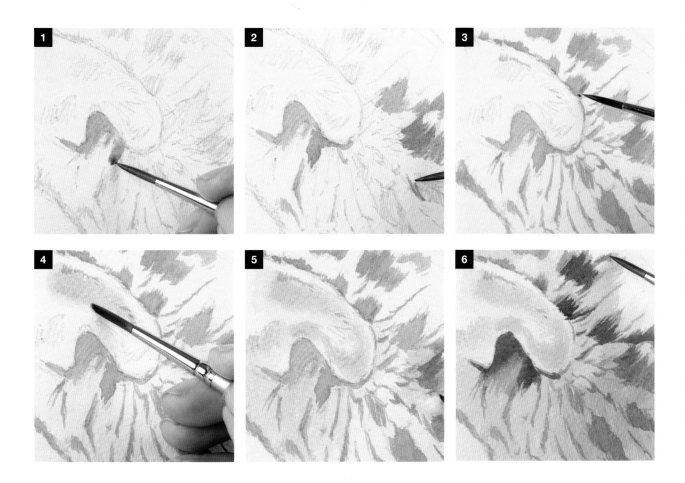

1 With your sketch in place, identify the medium tones (in this case, the spot markings) and use a size 4 round brush to apply a medium strength ink solution to these areas. Hold the brush at roughly forty-five degrees or so from the paper as you work, and make sure the brush does not run dry. You will begin to feel it drag a little if this is happening, in which case you should reload it.

2 Use fairly light strokes to begin to draw out the texture of harder, darker fur. Anything you put down now will stay, so even though this stage is simply an ink sketch, it's important to realise that it will build up into a part of the finished painting.

3 Once you have 'mapped out' the medium tones completely, you can begin to glaze the work. It will dry very quickly, but check it is dry before you continue.

4 For lighter-toned areas of softer fur, use the side of the brush to apply the ink to a small area, then quickly rinse the brush, squeeze out the excess water, then use the wet bristles to soften and blend the ink away.

5 The advantage of ink over watercolour is that it is permanent, so you can work over earlier areas of detail without the risk of it lifting away.

6 Once the mid and lighter tones are in place, you can use a dust-free eraser to remove the pencil markings. The darkest tones such as the cast shadow under the ear, and the centres of the dark spots, can then be added using a solution with more ink in it. Leave a little of the midtones showing round the edges of the markings.

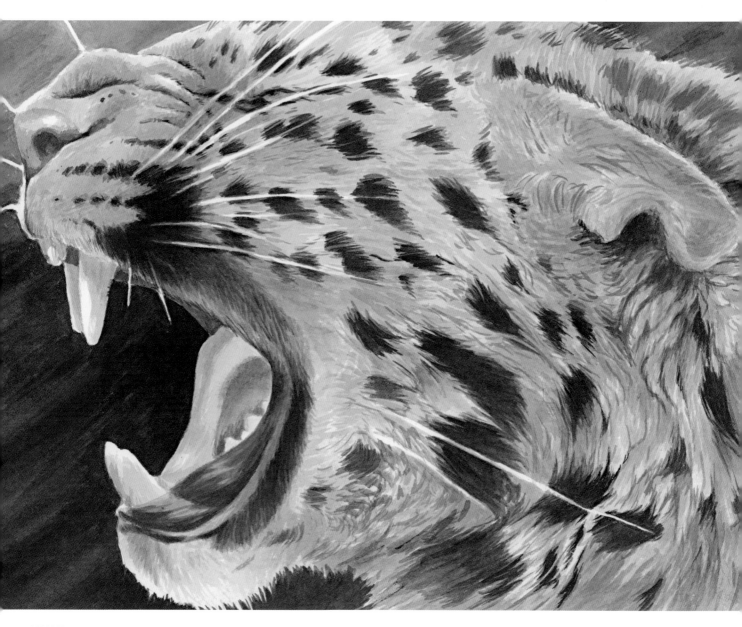

Wild Thing

Let's not forget that all cats, big and small, have powerful jaws and sharp teeth, making them the successful hunters that they all are.

Reserving highlights

If you want to use the paper as your highlight colour, you can either use diluted masking fluid to 'paint' in areas you want to reserve, such as whiskers, and remove it later, revealing the highlight. Alternatively, with a steady hand and a fine brush, you can simply paint around highlights. Even the most diluted ink will make these highlights visible. Personally, I prefer to paint around fine highlight areas like whiskers, as demonstrated below.

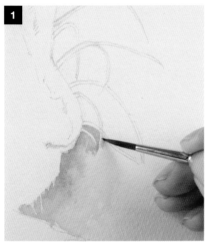

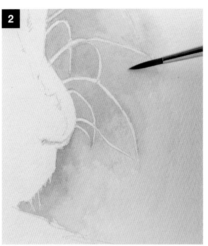

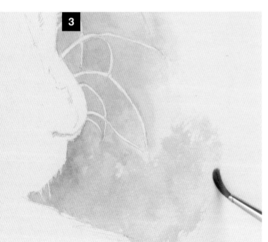

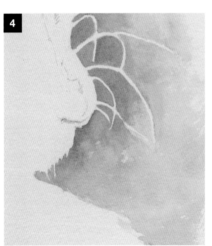

Phoebe
Indian ink has the ability to create strong highlights and transparent silvery grey tones, both essential when painting a white cat like Phoebe.

1 With your sketch in place, paint in the background using an even midtone solution of ink all over. Place the brush and draw it away from the outline.

2 Rinse your brush, squeeze out excess water and soften the ink away. Build up the background sections between the whiskers in the same way. Link the background as a whole by glazing some of the tone from one section over adjacent ones. This helps to create the impression that the background is one cohesive area.

3 You can create texture and interest in the background by using the brush fairly haphazardly. This is best to do further from the areas where you are reserving light.

4 Check the ink is dry and use repeated layers to build up the tone around the whiskers to create contrast.

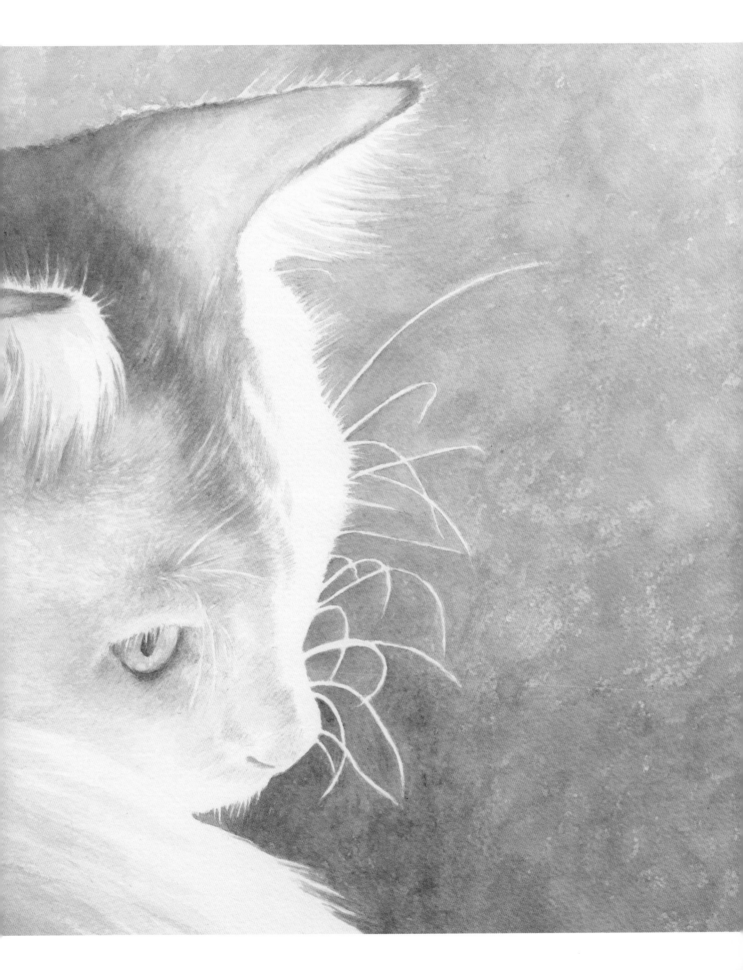

Khan – black leopard

Without doubt, the soft yet dark tones and highlights achievable with Indian ink make it an ideal medium for painting black cats, like Khan, a black leopard from the Wildlife Heritage Foundation. The subtle appearance of the black leopard's coat did not go unnoticed by one of my favourite authors either, as the quote below reveals.

'A black shadow dropped down into the circle. It was Bagheera the Black Panther, inky black all over, but with the panther markings showing up in certain lights like the pattern of watered silk.'

The Jungle Book – Rudyard Kipling

You will need

2B pencil
425gsm (200lb) Not surface watercolour paper
Masking tape, board and easel
Dust-free eraser
Indian ink
Size 4 round watercolour brush

The finished painting

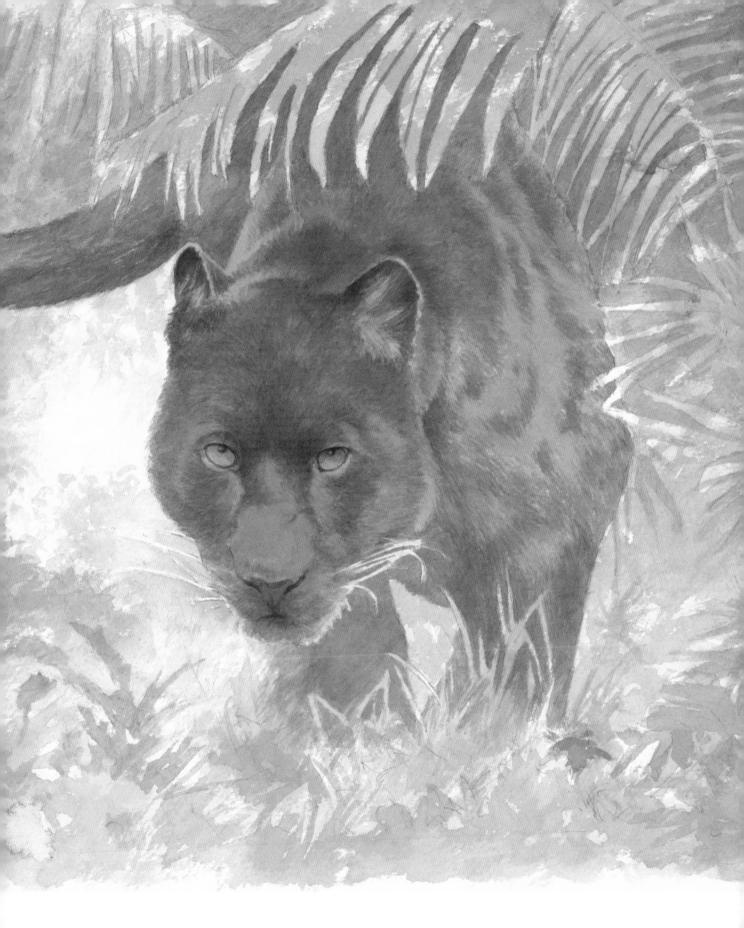

Reference

This photograph shows Khan, the black leopard, displaying both the stealth and wisdom of his fictional counterpart, Bagheera. All he lacks is a jungle to hunt in.

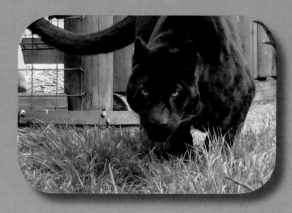

The reference photograph used for this painting.

Initial sketches

I wanted to create a painting of Khan in a jungle setting, focussing on his stealth as a hunter. Although I quite liked the pose in the full body sketch (below), it lacked the intensity of the head-on stare seen to the right. However, the full face sketch appeared much too passive, though I liked the additional foliage. I decided to use elements of both sketches for my final choice.

Painting

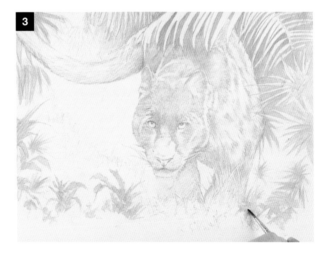

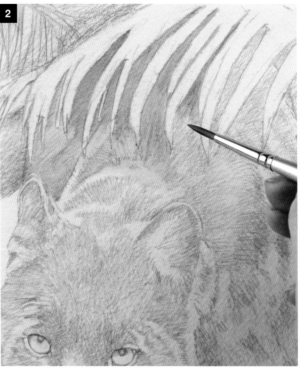

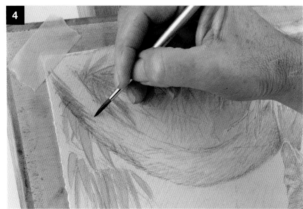

Tonal sketch

1 Draw your preparatory sketch using 2B pencil on to the paper and mount it on the board using masking tape. Place the board on your easel. It is important to create an accurate sketch before you begin; it will make inking the piece much easier.

2 Prepare a midtone solution of black Indian ink and use a size 4 round watercolour brush to begin applying it to the midtone areas. Start at the leaf fronds near the top and work downwards – this helps to avoid accidentally smudging the artwork with your hand as you work.

3 Continue working on the midtone areas of background foliage, filling in the areas between the leaves. Work the midtone in around the whole background.

4 Still using the midtone solution and the size 4 brush, begin to add tone to Khan himself, using a combination of linear strokes using the end of the brush and general shading using the side. Move your hand and wrist together to allow easy brushstrokes – do not make things awkward for yourself by trying to paint every stroke from the same position.

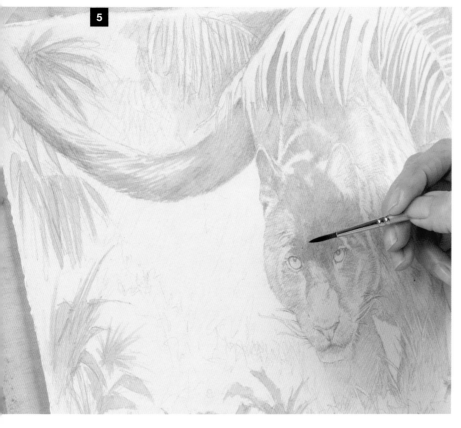

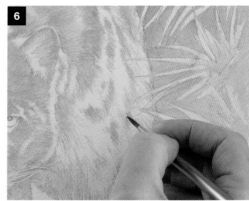

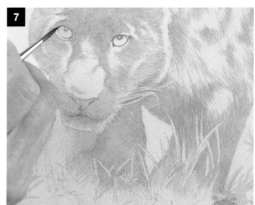

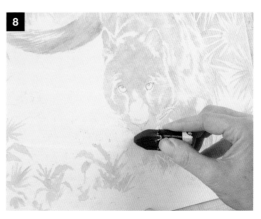

5 Map out the fur texture across the whole leopard using these strokes. This establishes patterns to be developed later on with glazing and layering. When working on the face, aim simply to establish the basic tone and shape of the shadows and highlights, rather than the texture of the fur.

6 Continue working over the remainder of the leopard. Use the tip of the brush to draw out the texture of the fur in the darker areas on the shoulder and leg, as the shape of the fur helps to highlight the leopard's musculature.

7 Still using the midtone solution of black ink, establish the grasses near his forepaw, reserving the highlights using the same approach as for whiskers (see page 102) by drawing the ink into the recesses. The same midtone can be used to establish the details on the eyes. Use the tip of the brush to colour the pupils and lining around the eyes.

8 Check the overall picture and touch in any final midtone areas, then allow to dry – this should take just a few moments. Use a dust-free eraser to remove the pencil from the painting. Retain a little of the whiskers on the left-hand side near the light area, so you can see them later.

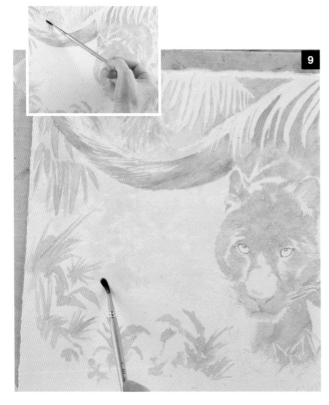

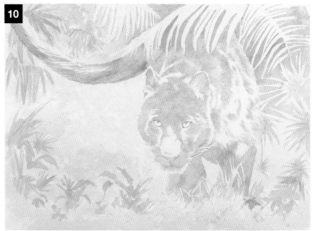

10 Continue until you have covered the background. You can suggest some details like grasses with brushstrokes made in the foreground using the same light-toned solution.

9 Create a very light-toned solution of black ink and use the size 4 to glaze the background, starting from the top left corner. Avoid a flat wash, which will appear dull and artificial. To help you get the loose, expressive strokes that will help to create a random feel to the foliage, hold the brush further back than usual, resting the end in the cupped palm of your hand (see inset). Leave some naturally occurring gaps and holes, and twist and move your wrist to create a fresh, loose feel to the background. Let the brush splay out, and use the whole length of the bristles.

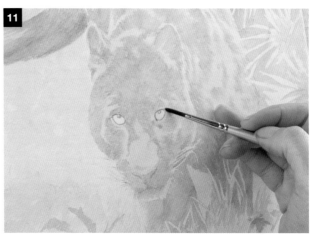

11 Glaze the leopard using the same light-toned solution and size 4 brush. Because the fur texture has been established, you need only reinforce the tone. Use more careful strokes, but work quickly to avoid creating lines. Glazing over all of the fur evenly will give the highlight areas some value, and strengthen the dark areas that are already in place. Give the eyes a glazing layer, too.

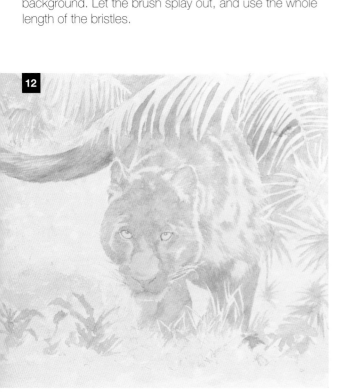

12 Try to create a dappled sunlight effect on the white leaves in the canopy above by using a hit-and-miss glaze of the light-toned solution. This completes the tonal sketch, with light, mid and darker tones.

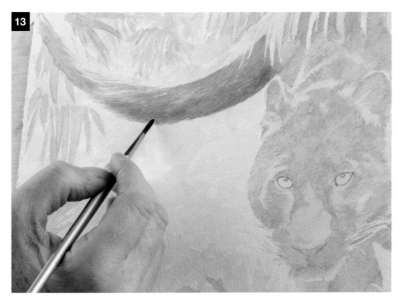

Developing the tonal values

13 Mix a darker-toned solution of ink and water and use the size 4 brush to develop the areas of shadow, starting with the tail. Use the end of the brush with light strokes to reinforce the fur texture you created earlier on. Pay careful attention to your reference to make sure you are placing the dark tones in the correct places. At the very bottom edge of the tail, do not work to the edge – leave a paler haloed edge to suggest light coming from behind the tail.

14 Begin to build up the fur on Khan's back, using short strokes and following the way the fur grows. These strokes suggest the shadows of the fur. Use longer, flatter strokes near the leaf fronds – background areas need less detail in general, and you want to avoid giving the impression that the leaves themselves are furry.

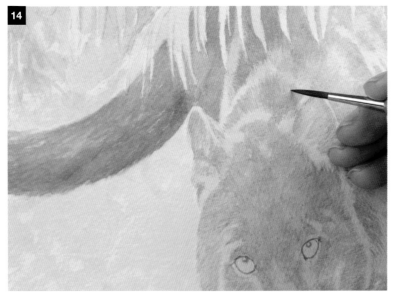

15 Work the darker-toned solution over the lighter areas as well as the darker areas, using the same short, controlled strokes that suggest the fur texture. Because the ink solution is translucent but permanent, the strokes keep the difference in tone apparent between the underlying light and dark areas.

16 Use the darker-toned solution to develop the insides of the ears, using negative painting to suggest hairs in the ears. Negative painting is done in a similar way to reserving the highlights (see page 102), except that you create shapes by leaving holes, rather than using shapes that are already sketched in.

17 Work over the upper part of the head, paying careful attention to the way the fur lies. As with the lower border of the tail (see step 13), leave a haloed edge around the cheeks.

18 Use the tip of the brush to establish some detail around the mouth and nose to complete the tonal values.

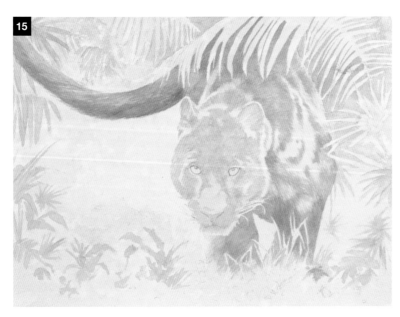

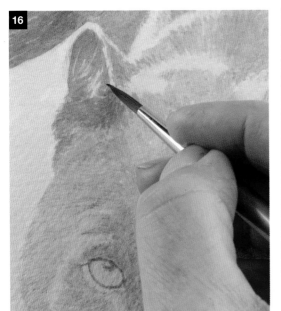

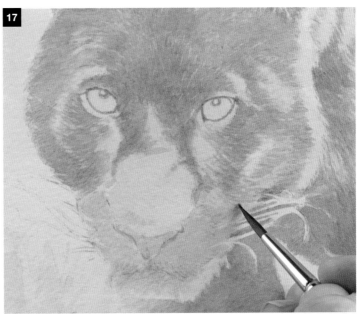

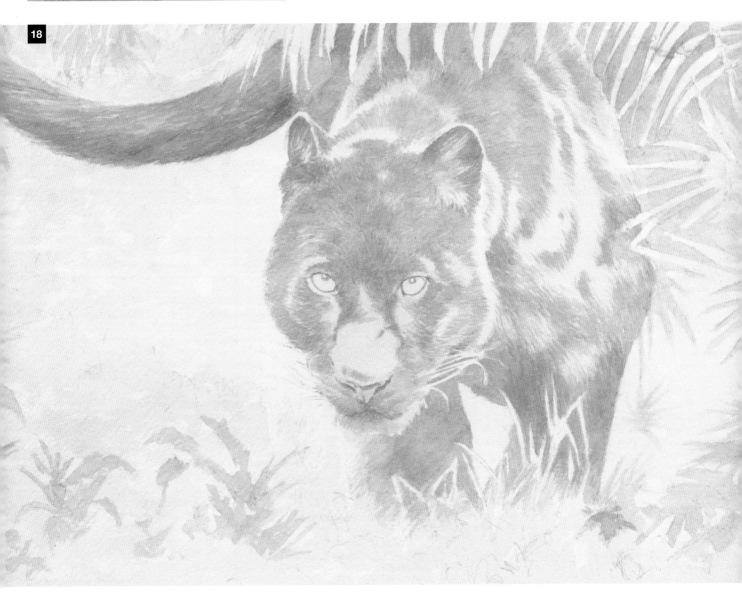

Adding contrast

19 The next stages involve adjusting the darkest tones to draw the viewer's eye where you want it to go. Holding the size 4 round brush cupped in the palm of your hand (see inset, step 9), and using loose, free strokes, add a slightly darker than midtone solution to the edges of the painting, with more in the corners. This helps to lead the eye towards Khan himself.

20 Use the brush with the same solution to develop the lighter area of background with subtle, loose strokes suggestive of foliage. As you build up the area, reserve the whiskers, using the light pencil marks you retained earlier to guide you.

21 Use the same darker than midtone solution to glaze and develop some of the shapes you have created in the background. Make sure to keep them relatively loose and do not add too much detail, or you risk distracting the eye from the leopard.

22 Prepare a light-toned solution, and lay a piece of scrap paper with a straight edge over the top left corner of the paper as shown, avoiding the tail.

23 Use the size 4 round to apply a glaze to the area, then quickly remove the scrap paper, rinse and squeeze your brush and soften the edge away.

24 Lay the scrap paper back up, aligning it with the edge of the glazed area, and repeat the process, this time below the tail. Repeat on the other side to create the impression of a shaft of sunlight coming through the canopy.

25 Add one or two more shafts of light to the background in the same way.

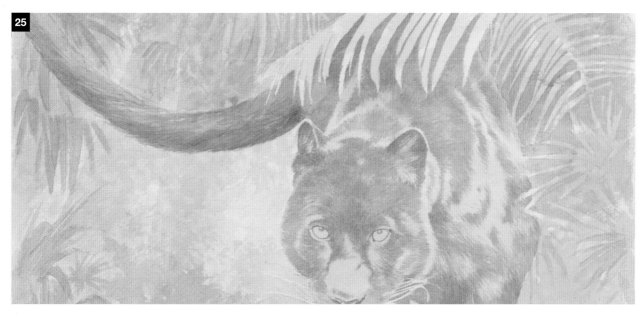

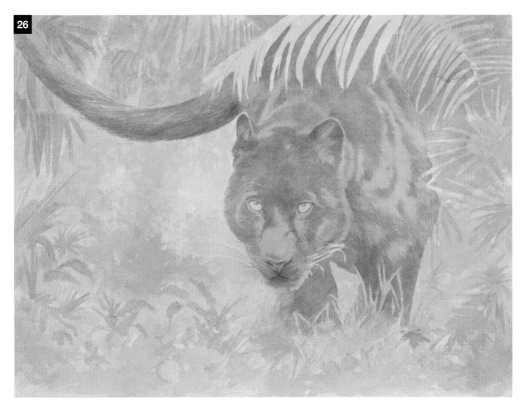

Finishing touches

26 Mix a midtone pale grey solution and glaze the leopard, covering the whole body and face except for the eyes and whiskers. You can work over the grasses in front of the leopard, too. This technique strengthens the tone but does not obscure the fur texture, which makes it a quick way of adding impact.

27 Darkening the leopard has made the overhanging leaves too light in contrast, so use the same pale grey solution to add dappled light over the midground canopy.

28 Add more ink to create a darker grey solution, and use the end of the brush to strengthen the facial details. Work carefully, developing a shadow around the forehead, and adding darker hints to the ears, eyes, nose and mouth.

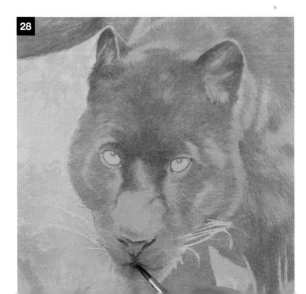

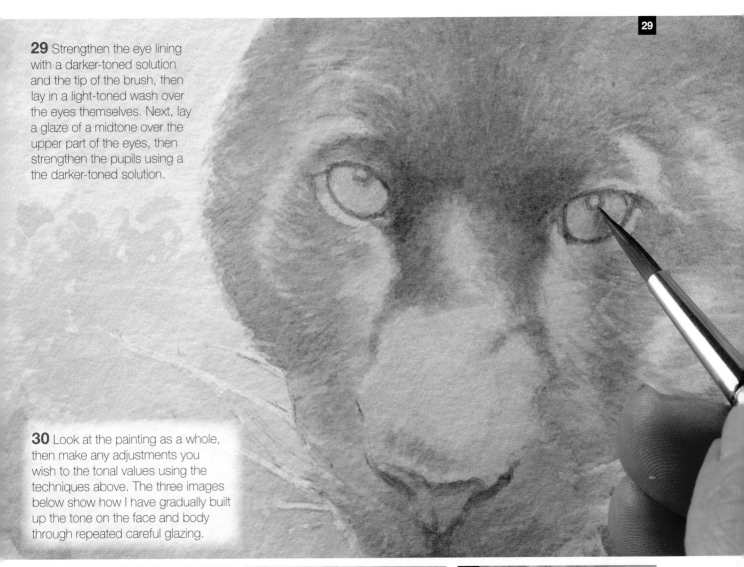

29 Strengthen the eye lining with a darker-toned solution and the tip of the brush, then lay in a light-toned wash over the eyes themselves. Next, lay a glaze of a midtone over the upper part of the eyes, then strengthen the pupils using a the darker-toned solution.

30 Look at the painting as a whole, then make any adjustments you wish to the tonal values using the techniques above. The three images below show how I have gradually built up the tone on the face and body through repeated careful glazing.

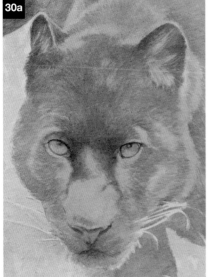

30a

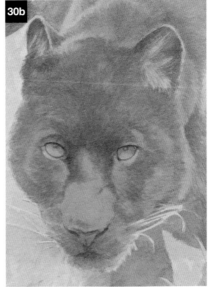

30b

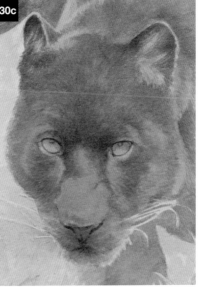

30c

The finished painting can be seen on pages 104–105.

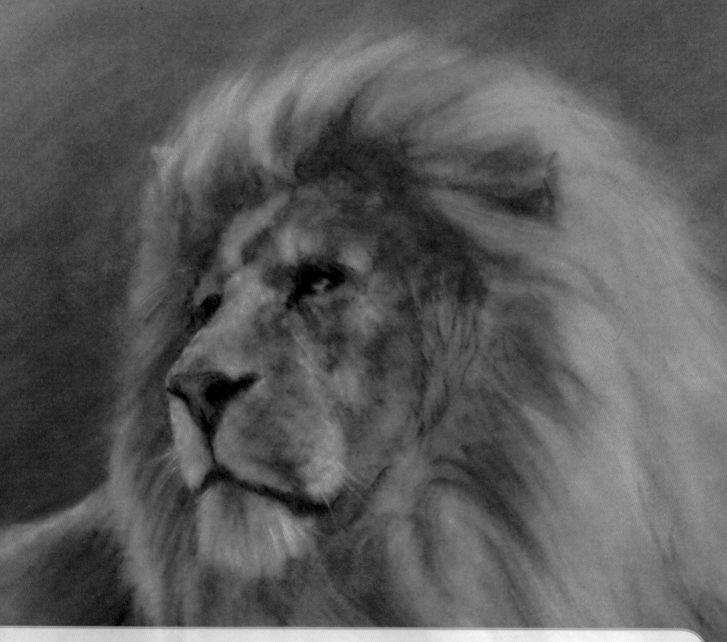

Pastels

Pastels are essentially paint pigment on a stick, held in place with a gum binder. They are not to be confused with the coloured chalk traditionally used on school blackboards.

 The use of pastels requires both drawing and painting techniques, and are, therefore, the ideal transition from one skill to the other. In addition, the softness of pastels lends itself perfectly to the soft, furry textures of animals, especially cats. As an extra bonus, pastel artworks generally last longer than other painting media, as there is no oil or water content to crack or fade the finished product.

Manzi

Sepia and ivory hard pastels help to focus on the tonal values in this pastel sketch of an adult lion. Velour paper allow you to add colour on top in glazes if required.

Materials for pastel painting

Hard pastels These are bought as square-shaped sticks. They include more binder, which helps them to keep their shape and make them harder than other pastels. This makes them ideal for fine detail work.

Soft pastels These are also bought as sticks, but soft pastels are usually round in cross-section. They contain less binder than hard pastels, and so deposit colour more readily. This makes them ideal for covering larger areas.

Velour paper Pastels work best on a textured surface. I like to use velour paper, which is made up of acid-free backing paper covered with very short, coloured nylon fibres. It is available in many colours and different tones. I commonly use sand-coloured, grey and black velour paper.

Very soft pencil A standard pencil is too hard to work well on velour paper. A charcoal pencil or 9B graphite pencil that will not scratch or indent the paper is ideal.

Kneadable putty eraser Softened in your hands, a putty eraser can be used to lift out small areas of pastel.

Easel, smooth board and masking tape A smooth board is essential in order to avoid picking up patterns from a grainy board whilst rubbing the pastel into the paper. MDF board is ideal. Masking tape is used to secure the velour paper to the board.

Pastel techniques

Pastel technique is very straightforward, making it one of the easiest media to learn. There are sticks of prepared colour which can be blended and mixed by rubbing, or, in the case of velour paper, by layering. There is no need for brushes or a medium in which to dilute the colour: application is direct from pastel to paper and the effect is immediate.

Setting up for pastels

It is quick and easy to get ready to use pastels. Simply use medium-tack masking tape to secure the corners of the velour paper to a piece of smooth, hard board (such as MDF), then equip yourself with a selection of hard and soft pastels. That's it – you are all set to start your artwork.

Paws for thought

Using pastels on velour creates very little dust, and is, therefore, a great combination for people with dust allergies or breathing problems.

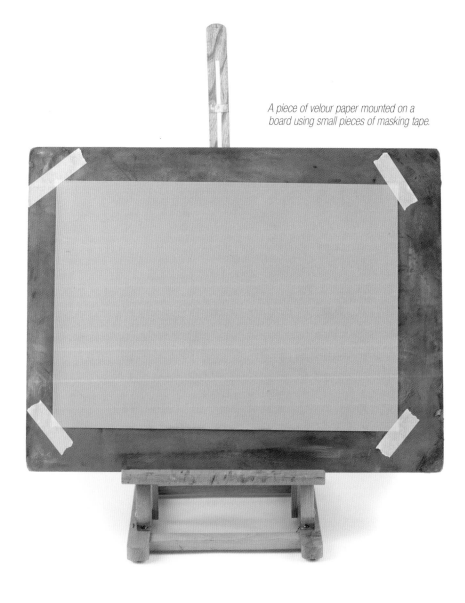

A piece of velour paper mounted on a board using small pieces of masking tape.

Preparing hard pastels

For fine, detailed work, new hard pastels can be used straight out of the box. For more general use, looser sketching and broader painterly strokes, they need to be 'bedded in' using the process described below.

1 The hard pastels I use start as 8.5cm (3¼in) long sticks. This is fine for sketching lines, but of little use when using the long edge. I suggest you snap each in two so you end up with two smaller, more usable sticks. The exact length of each part does not matter too much as long as they are relatively even.

2 Hard pastels have a protective waxy coat on the edges (see inset). This needs to be removed before they are ready to use. The best way to remove this is to stick a piece of masking tape on the edge of your board and rub the edge of the pastel on it until the surface appears matt.

3 In order to avoid depositing a big blob of pastel on your paper when you begin, run your finger down the pastel to remove any excess pastel dust from the dulled surface before you use it.

Using hard pastels

Hard pastels can be used for drawing shapes and lines exactly like a pencil or a stick of charcoal. They can also be used for shading, and, due to their hardness, lend themselves particularly well to soft, transparent layering or glazing.

1

2

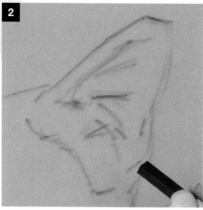

3

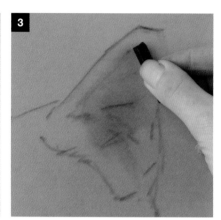

4

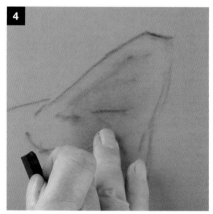

5

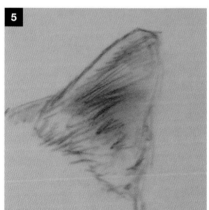

1 You would not sketch with a very sharp pencil, and likewise you should not sketch with the sharp corner of a hard pastel. Abrade one of the corners on the piece of masking tape (see step 2, on page 119).

2 You can now use the rounded corner exactly as you would a reasonably soft pencil. You can adjust the thickness of the line by changing the pressure you apply with your hand. For sketching, use a medium pressure to apply a line that is strong enough to show through following layers, but is not so strong that it becomes too thick and dark.

3 The flat edge of the pastel can be used to apply tone over areas (this is why you snap the stick into smaller pieces). It's better to add two or three layers to build up tone than one strong layer – just in case you go too far.

4 Use a clean fingertip to blend the applied pigment into the surface. The velour paper is self-fixing and will help prevent smudging, while still allowing smooth blending.

5 You can use the sharp, unrounded corners of hard pastels to add fine detail such as hairs.

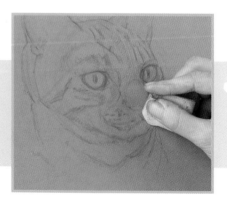

Paws for thought

A putty eraser can be used to soften or remove pastels from the paper. Use a dabbing motion to press and lift the pastel away, not a rubbing motion. You can also use the fine nozzle or small brush attachment on a vacuum cleaner to clean your velour surface – but make sure the paper is stuck down securely, with masking tape all the way round.

Using soft pastels

Soft pastels are better than hard pastels for applying layers of colour because they go on to the surface more easily and smoothly. Soft pastels do not tend to have a protective coating, but many have a paper wrapper – remove this. As with hard pastels, snap your soft pastels in two to give a more useful size.

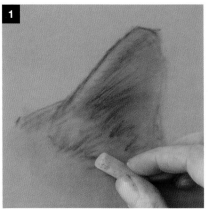

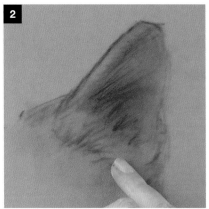

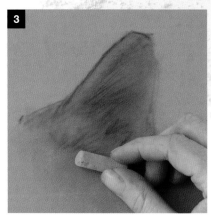

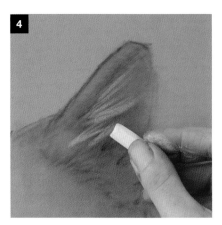

1 Soft pastels are applied in much the same way as hard, but less pressure is needed to transfer the pigment from the side.

2 Similarly, they can be blended in using your finger. Rub until your fingers feel like they're heating up to ensure you are pushing the pigment into the paper surface.

3 Soft pastels work best when built up gradually to create smooth transitions of tone.

4 You can add details like these white hairs using the edge of soft pastels with light pressure. Note that they will not be as sharp and fine as those added using a hard pastel.

5 The edge of soft pastels is excellent for adding visible highlights, as the line is clear but not sharp.

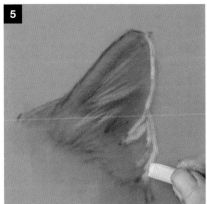

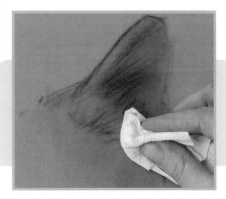

Paws for thought

Although velour paper is soft, it is still abrasive. If you don't like the sensation, you can use a piece of kitchen paper to blend the pastel into the surface.

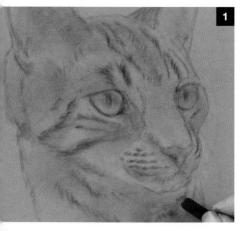

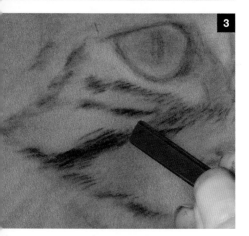

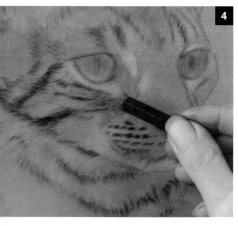

Hard fur

Hard pastels are very versatile. In addition to letting you establish the tone and line of your artwork, you can use them to produce the coarser fur on some cats, like this tabby.

1 Build up your sketch using the rounded corner of a hard pastel, and add some tone with the side.

2 Add your colour and tone to get the softer underlying fur established. Use midtoned pastels for this – the lightest and darkest tones need to be reserved for the hard fur. For example, any highlights you add at this point should be subtle, and applied with ivory at this point, rather than white.

3 Once you are satisfied, use the sharp corner of the darkest toned hard pastel (black, in this case) to apply small sharp strokes in the dark areas of the fur. When the sharp corner becomes blunt, you can turn the pastel to use the other sharp corners. Once these are all blunt, you can either use fine sandpaper to sharpen the pastel, or snap off as short a length as you can manage to reveal four new sharp corners. Note that there is no increase in pressure needed to make these short strokes – as long as you use a sharp corner of the pastel, the lines will remain clear and strong. Be careful with the placement of your strokes and make sure they follow the direction of growth to achieve a realistic effect.

4 Make still shorter strokes on the midtoned areas of the fur. These create the rougher texture on these areas. Avoid making a flat uniform layer of these short strokes – pay attention to your reference photograph to make sure you are accurately simulating the shape of the cat and its fur.

5 Adding the black strokes on the midtone areas will darken them, so add contrasting highlights using a hard white pastel to bring the tone back. The high contrast helps to create the stark effect. You can add the occasional highlight in the dark fur areas to help suggest the glossiness of the hairs, but keep these to a minimum.

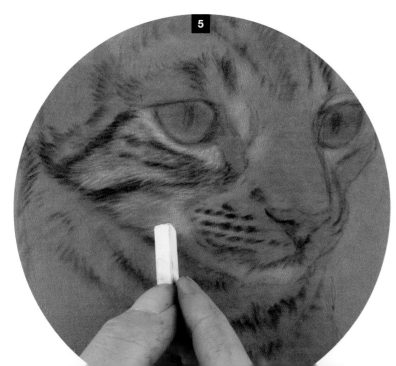

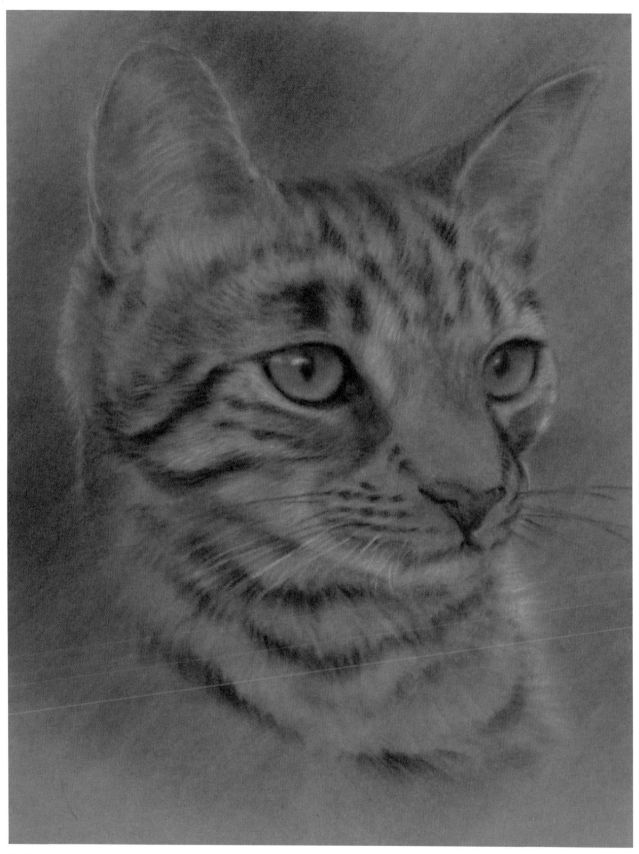

Ned

This pastel sketch of Ned, a silver tabby, was created using mostly hard pastels to suggest his hard, straight fur. Using a dark grey velour adds a unifying tone to his coat and the background.

Soft fur

When creating the effect of soft fur, the velour surface will provide the shadows. For this reason, and because it is very hard to keep clean, avoid a white velour surface.

A good general rule is to use a cool blue or grey paper for cool white fur such as white lions and snow leopards, and a warm sandy colour for warmer fur like ginger cats, African lions and tigers.

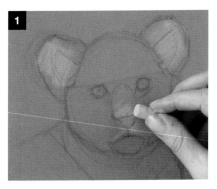

1 Keep your sketch simple when using pastels for soft fur; stick to very basic shapes and features, or you risk detail showing through later. With your sketch on the paper (this was made with a 7B pencil), apply the side of a soft English red pastel (or appropriate colour) to areas where skin will show through, such as the muzzle, nose and inside of the ears.

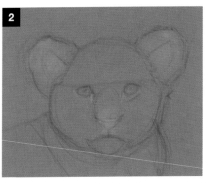

2 Use a clean finger to rub in the colour to secure it, and reinforce any areas that require it with a second or third layer of pastel until the tone is correct.

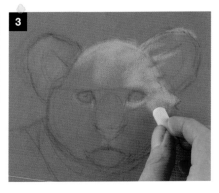

3 Fill in the fur, using the side of the white pastel to cover large areas, and the edge for smaller areas. Work gently at first, and build up the tone gradually. Leave the underlying paper showing through in shadow areas. The features of a young animal like this white lion cub are not as pronounced as in an adult, so avoid the temptation to overdraw features; use soft, gradual blending. Soft pastels are ideal for this.

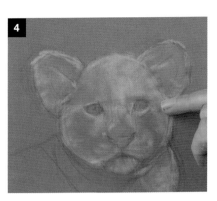

4 Smooth in all of the first layer of soft pastels using a clean finger.

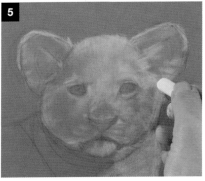

5 As you apply successive layers, use the edge of the pastel to add relatively fine lines in the direction that the fur grows. Smooth in the lines, then continue building up the fur. Where the fur colour (white) overlays the skin colour (English red), you will notice a smooth colour blend. Successive layers can partially cover this, gradually strengthening the effect of soft fur.

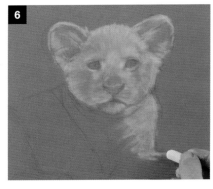

6 Successive layers of pastel strengthen the colour, so work on building up the contrast between the shadows (the bare surface), midtones (one or two layers) and highlights (multiple layers that obscure the underlying paper) with very small strokes that are blended in as you work. Remember to keep some lines visible to prevent the image being too soft and directionless, and leave the areas of shadow clean.

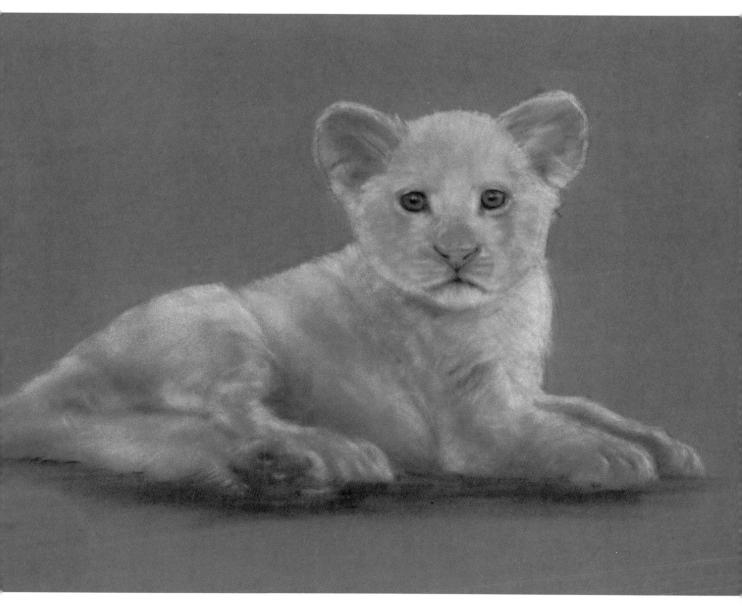

White Lion Cub

Soft pastels can suggest, rather than show, soft fur textures when used loosely. The only hard pastels used in this white lion cub sketch were to enhance the eyes and nose.

🐾 **Paws for thought**

Very soft pastels – especially white – can deposit small particles on the surface as you work. Before you rub it in, gently blow these away. Dry your mouth beforehand – the last thing you want is to get the surface wet.

Burying whiskers

Hard white pastel is excellent for adding defined white whiskers.
However, you need to get the hard white stroke to disappear
into the face where it grows out of darker fur, or it will look stark
and artificial.

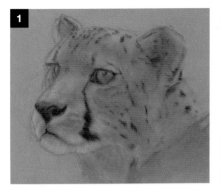

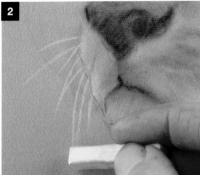

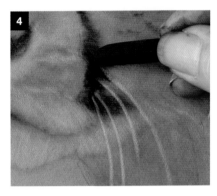

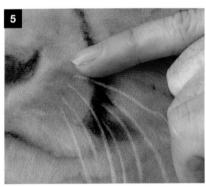

1 Build up the picture until the area where the whiskers will sit is complete.
If you add whiskers too early, you can lose the sharp, pristine detail.

2 Use the sharp corner of a white pastel to place any whiskers that will be
hidden by the face (those on the left here). Check the length and attitude of
the whiskers (see page 32), and remember that whiskers are shorter towards
the front of the face, and longer towards the back. Use smooth single strokes,
and lift the pastel away at the end to create a subtle taper.

3 On the visible side of the face, identify from which point each whisker will
emerge before you place it. Again, add it with a clean stroke and lift away.

4 On dark areas, apply very short fine strokes of the black pastel to the point
where each whisker emerges from the face. Make the strokes in the same
direction as the whisker itself. Soften the black pastel in.

5 On light areas, apply the whiskers in the same way, but there is no need to
add additional colour at the base – you can simply soften the end into the fur
or background colour.

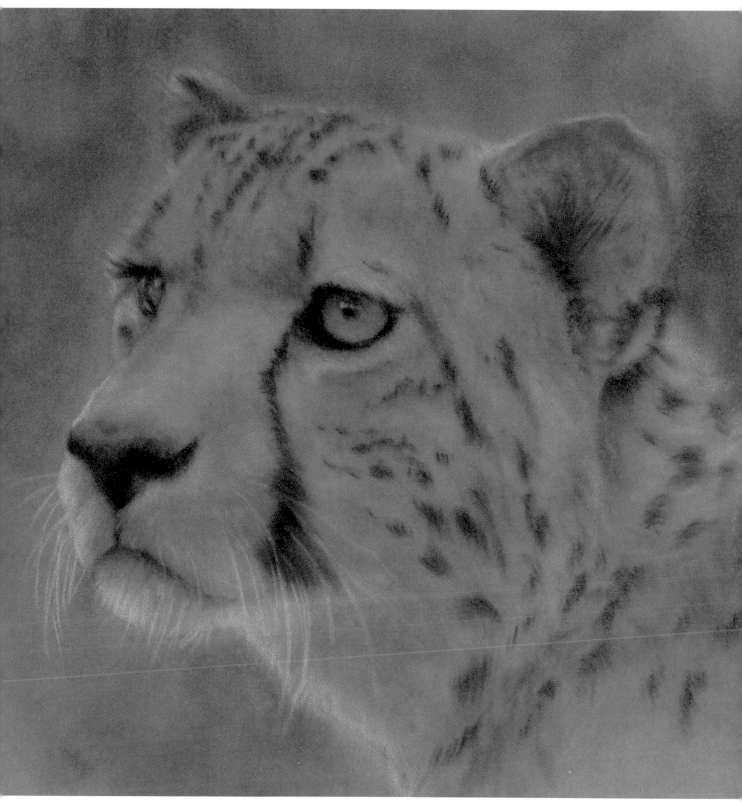

Murphy
This pastel on velour sketch of this cheetah has been kept deliberately simple. A dark background tone and strong highlights enhance the sketch, without the need for too much detail work.

Forrest – domestic kitten

The combined softness of pastels and velour paper is ideal for creating the soft fur and gentle kitten eyes of my own ginger cat, Forrest, known affectionately as 'Fozzie Bear'.

The tone of the sand-coloured velour paper shines through the light layers of pastels to enhance the warmth in the ginger fur. These warm tones will be further complemented by introducing areas of cool violet in the background, as well as in the cooler areas and shadows of Forrest himself.

You will need

7B pencil

Sand-coloured velour paper

Masking tape, smooth board and easel

Hard pastels: sanguine, cold grey, black, white, burnt sienna

Soft pastels: pale dioxazine violet (tint 8), orange (tint 5), English red (tint 7), dark orange (tint 3), sap green (tint 5)

Opposite:
The finished painting

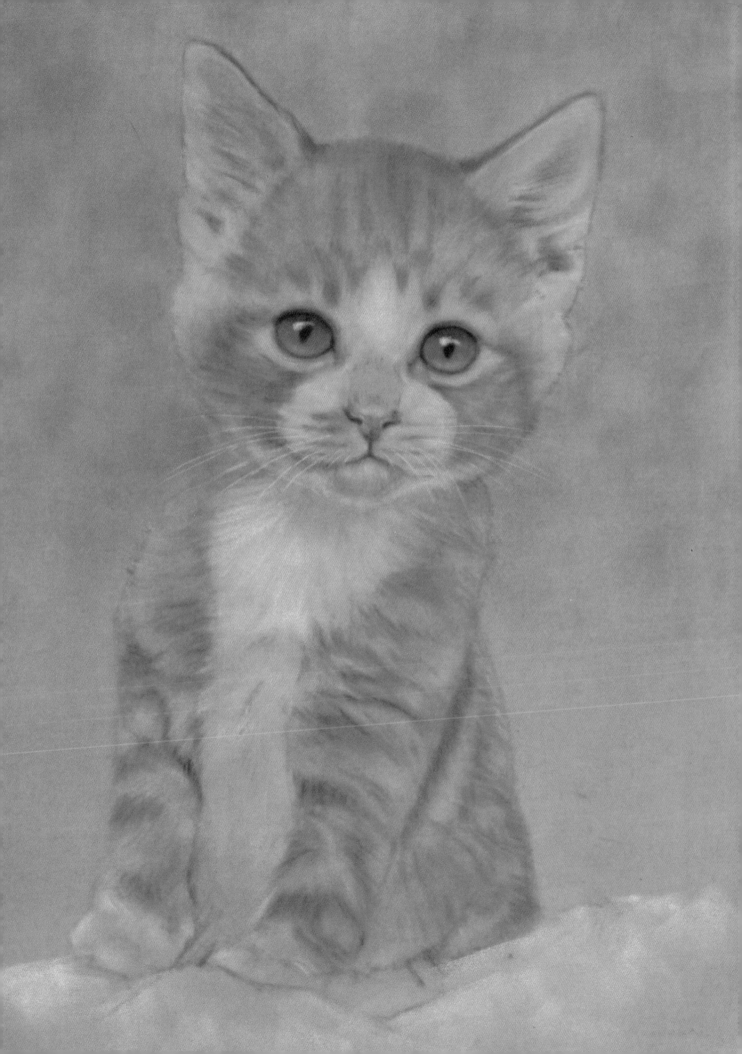

Reference

Forrest was one of a litter of three kittens that we hand-reared. Because of a pronounced head-tilt and very wobbly gait, we decided to keep him. He is now like any other healthy cat, and is probably the boss of our feline gang!

Initial sketches

Of course, any drawing or painting of a kitten will have enormous appeal, regardless of the pose. The naughtiness in the full body sketch (below) works well as it stands I think, without further embellishment. The other portrait sketch (bottom) is, however, quite static. My final choice shows more of that slight head movement of a curious kitten.

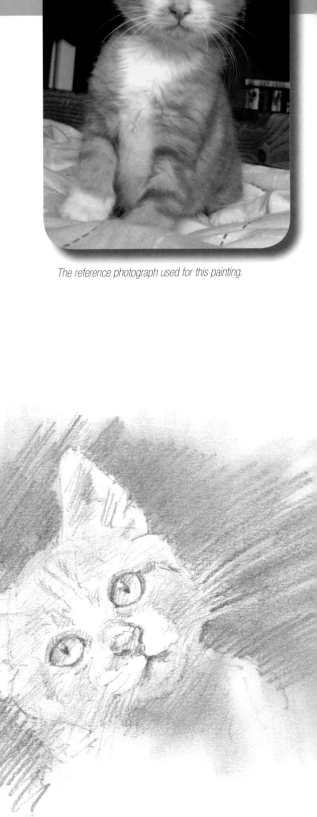

The reference photograph used for this painting.

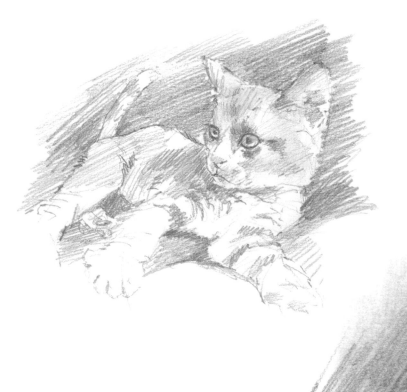

Painting

Tonal sketch

1 Draw your basic shapes on to the velour paper using a 7B pencil, then mount it on the smooth board using masking tape. Place the board on the easel, then reinforce the basic shapes, adding a little more detail using the rounded corner of a sanguine hard pastel.

2 Because there is no black in Forrest's fur, we will use the side of the sanguine hard pastel to establish the basic tones. This will retain the warmth of the image. Start on the head, and apply the pastel in multiple light layers to create the impression of smooth, soft fur. Rub each layer in with your fingers as you work.

3 Leaving the white areas as blank velour paper, continue to establish the warm tones of the ginger fur. You can keep this application quite light and flat – there is no need to start creating textures yet. Instead, concentrate on establishing the tones in the right places.

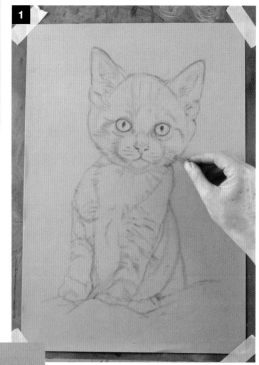

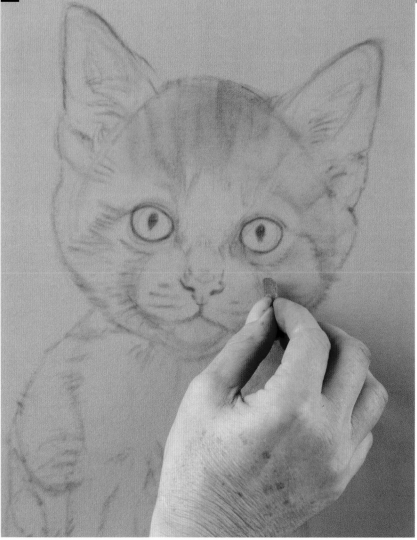

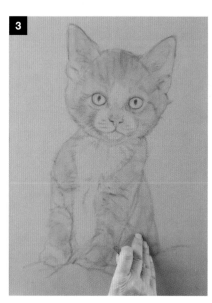

Background

4 Use a hard black pastel to establish tonal variations in the upper two thirds of the background. Apply it lightly and haphazardly to retain the soft feel of the picture. Work up to and slightly over the outline of the kitten.

5 Soften in the black pastel with a clean finger, then cover the whole background with a pale dioxazine violet soft pastel, applying it in two or three light layers in the same textured way as the black. The underlying black will deepen the tone to create an interesting but not distracting gradated background.

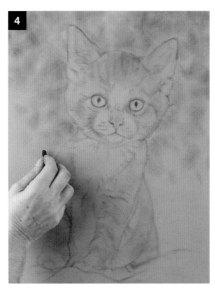
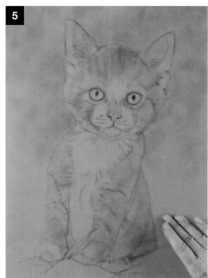

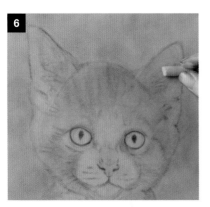
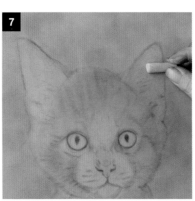

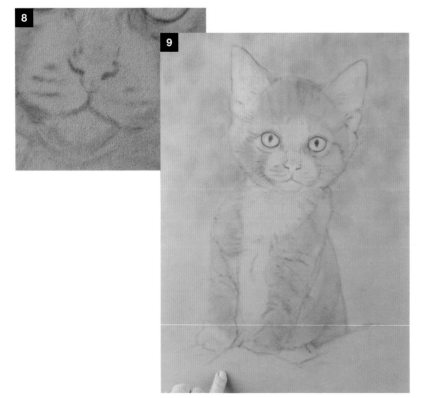

Basic colours

6 Use the orange soft pastel to bring out the vibrancy of the ginger fur areas. Keep the colour vibrant, as it will be subdued and muted by subsequent layers. Use the side for large areas of colour and the edge for smaller areas.

7 Add English red soft pastel to the inside of the ears, then soften it in and add pale dioxazine violet soft pastel over the red. Blend it in to add a sense of the ambient light and to add a cool tone in the ears. We have also used this colour in the background, which creates a sense of harmony between subject and background.

8 Add and blend English red soft pastel on the nose and mouth area, and pale dioxazine violet soft pastel to the bridge of the nose to cool this area.

9 Add the shadow values to the white fur using dioxazine violet soft pastel. Make smaller, more controlled marks in these areas using the edge of the pastel. These are mainly restricted to the neck, belly and paws as shown, but there are also small areas around the eyes. With the shades established on the white parts of Forrest's fur, block in some vague shapes on the blanket with the same pastel and smooth them in, maintaining the overall balance of warm and cool hues.

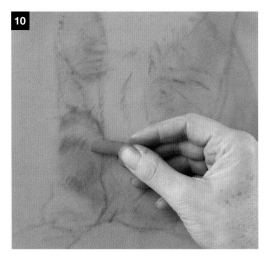

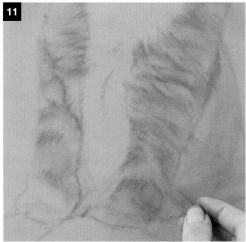

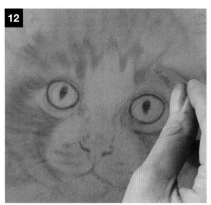

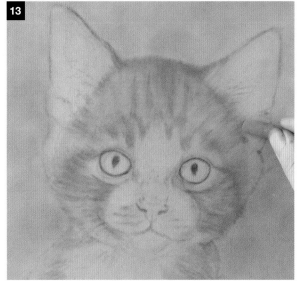

Developing details

10 Using the edge of the dark orange soft pastel and the soft fur technique (see pages 124–125), stroke softly in the direction of the fur's growth to develop the darker orange stripes.

11 Kittens' fur is very soft, so use only medium pressure to avoid creating hard lines. Soften the colours in as you work over Forrest's coat. It is easy to get lost with stripes and other markings, particularly on soft fur. Use the underlying faint pencil marks of your sketch to help guide you and refer often to your reference photographs.

12 Pay particular attention to the fur direction as you add the markings on the head, as the face is an important focal point. All tabby cats have a roughly M-shaped mark above and between their eyes. Pay attention to your reference photograph, as this can be more or less obvious.

13 At the edge of the head, the fur appears slightly darker against the background and the ears as the head curves away. Keep the darker fur here soft-edged, but add more layers to darken these areas, softening each subsequent layer in turn.

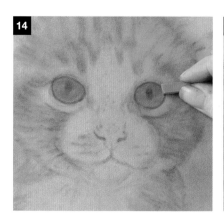

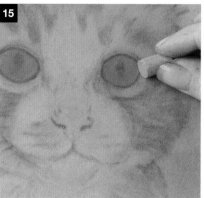

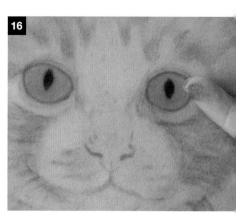

14 Break a 2.5cm (1in) section of cold grey hard pastel and use the side of it to add a base colour to the eyes, changing to a rounded corner for small areas. Make it slightly stronger than you want the finished effect to be, as rubbing it in will soften the value.

15 Add a few hints of green to the eyes using the edge of a sap green soft pastel, and soften it in.

16 Re-establish the pupils using a rounded corner of the black hard pastel. Resist the temptation to establish the pupils as solid black by using heavy pressure – build them up gently in layers. On such a small area, it is very hard to rub the pastel into the velour surface, so simply press each layer down firmly with an unmoving finger.

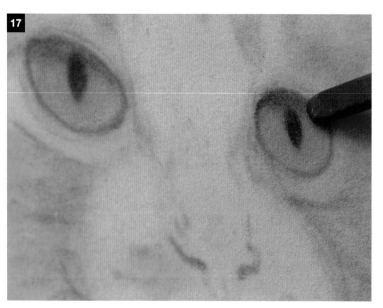

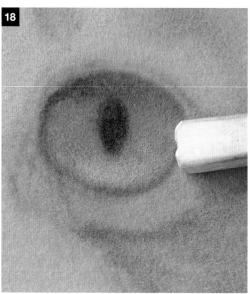

17 Add the shadow of the eyelids with extremely faint strokes of the black hard pastel – aim for a glazing effect that lets the colours beneath shine through. The pastel should just barely skim the surface for each layer.

18 Add the highlights at the bottom of each eye using the rounded corner of a white hard pastel. Follow the curve of the lower eyelid.

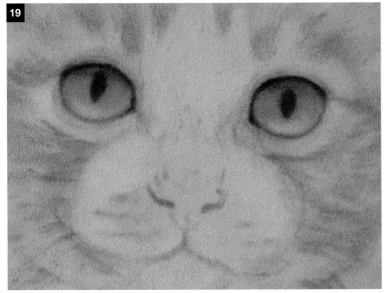

19 Use a sharp corner of the black hard pastel to strengthen the rim of the eyelid. The darkest part is the lower edge of the upper lid, as this is in shadow. This completes the eyes for the moment – adding the final reflective highlights at this point is tempting, but they should be added right at the very end to avoid the risk of dulling or smudging these finishing touches.

20 Use the edge of the English red soft pastel to add a little pink to the tear ducts, then add shading to the lower part of the nose leather with the sanguine hard pastel.

21 Use the sharp corner of a burnt sienna hard pastel to re-establish the nostril line, then add the dimple and shadowed cleft in the nose down to the lips. Use the same pastel to add the shadow of the lips, feathering out the line as it starts to get hidden in the fur further from the centre. Soften each section in turn as you work.

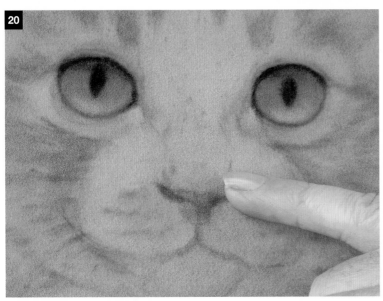

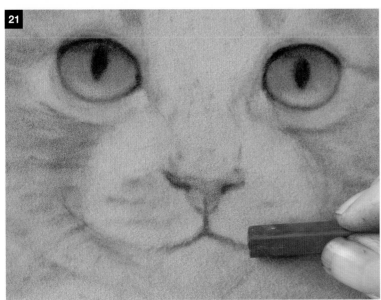

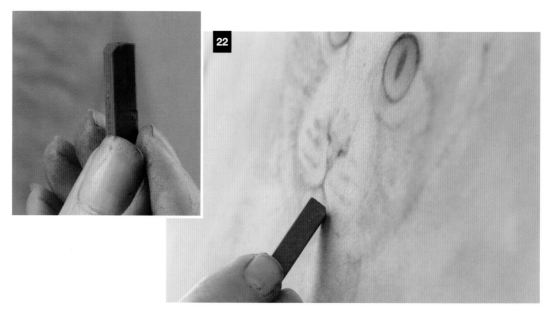

Adding contrast

22 Flatten one of the ends of the burnt sienna hard pastel as shown, to form a flat chamfered edge (see inset). This can be used to add soft marks, even with a hard pastel. Apply it very lightly to the four rows of whisker follicles, just to give a faint impression – do not apply the pastel too strongly. Do the same to add short defining shadows to the sides of the nose and the lower parts of the cheeks and chin.

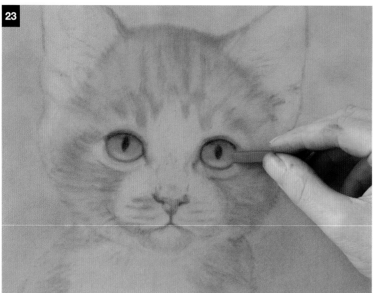

23 Still using the chamfered edge of the burnt sienna hard pastel, gently suggest some shadow around the tear ducts and upper parts of the eyes. Change to one of the remaining sharp corners for the lower parts of the eyes. These dark touches help to recess the eyes and add depth to the features.

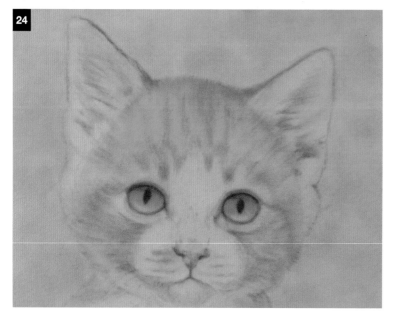

24 Use the rounded edge of the burnt sienna pastel to begin to add detailing around the ears, including establishing some shadowed hairs inside the ears. Build up some very subtle dark areas in the fur around the head. This added contrast will direct the viewer's eye towards the focal point (i.e. the head) in the finished picture. However, it is crucial to keep this contrast soft throughout the painting.

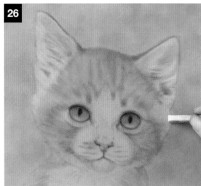

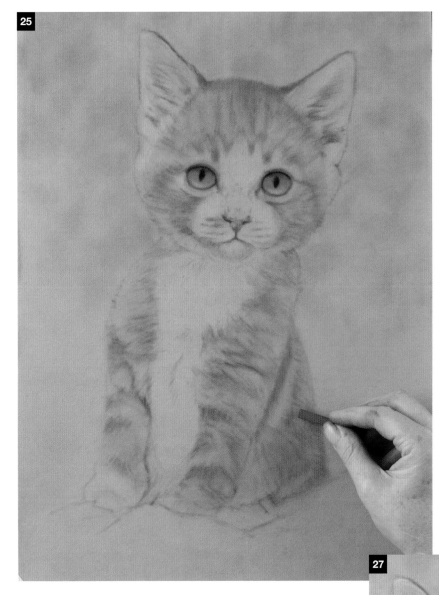

25 Add similar contrasting touches across the body in shadowed recesses to bring out any angles and creases in the fur (these are particularly pronounced at limb joints), but make these very subtly and softly to avoid drawing the eye away from the head.

26 The next stage is to add the highlights. As mentioned earlier, these are left until last to give them the best chance of staying clean and strong. As a result, rub a hard white pastel down to a chamfered edge (see step 22). Use the chamfered edge to add highlights, starting at the top around the ears, and working downwards to keep things clean. The sand-coloured paper will give the white highlights a creamy, soft quality.

27 Continue using gentle, repeated strokes to apply the chamfered edge of the hard white pastel to the face, softening it in lightly as you go. Pay attention to the direction of growth of the fur as you work, and keep your highlighting touches following those directions.

Paws for thought

The instinct may be to use a soft pastel for highlights on soft fur like Forrest's, but even light touches can leave strong, overpowering marks. A hard pastel will resist depositing the pigment more than a soft pastel, and so is a good choice to add controlled soft highlights.

28 Build up the fur on the chest and paws with the same pastel and technique. The fur on the chest is longer, so use slightly longer strokes. Use the full width of the chamfered edge in order to create large numbers of hairs at once – trying to add lots of very fine individual hairs will ruin the soft impression of the fur. The chamfered edge can also be used extremely lightly on the ginger areas and softened in to give fine blended highlights here.

29 Use the side of the soft white pastel to block in the suggestion of texture and light on the blanket. Use a clean finger to soften any hard edges.

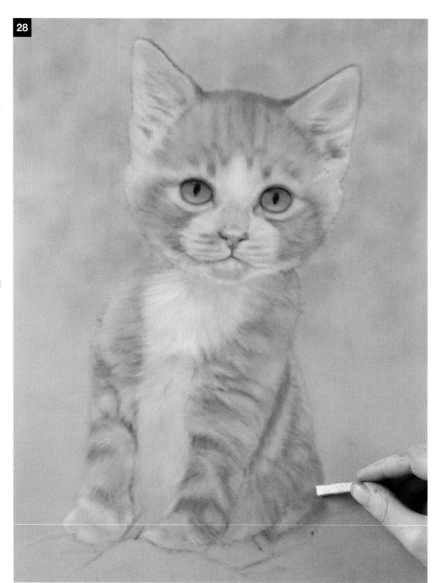

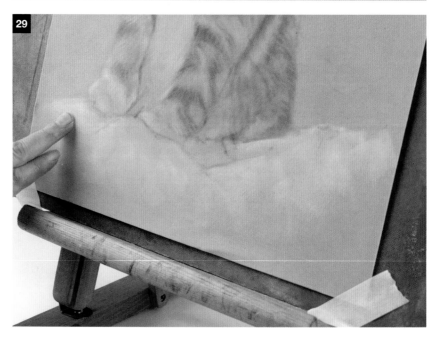

30 Add tiny final highlights to the nostrils using a rounded corner of the hard white pastel, then use a hard corner to add the whiskers – shorter at the front, longer at the back. Soften in the roots as described on page 126.

31 To finish, use a sharp corner of the white pastel to add a small, high impact, comet-shaped reflection to each eye. This helps to show the curvature of the eyes.

Paws for thought

Before you declare the picture finished, squint at it. If you can not see the highlights in the eyes, strengthen them until you can. This ensures the finished piece has a strong impact.

The finished painting can be seen on page 129.

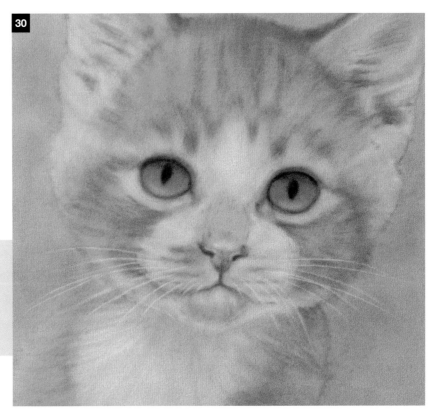

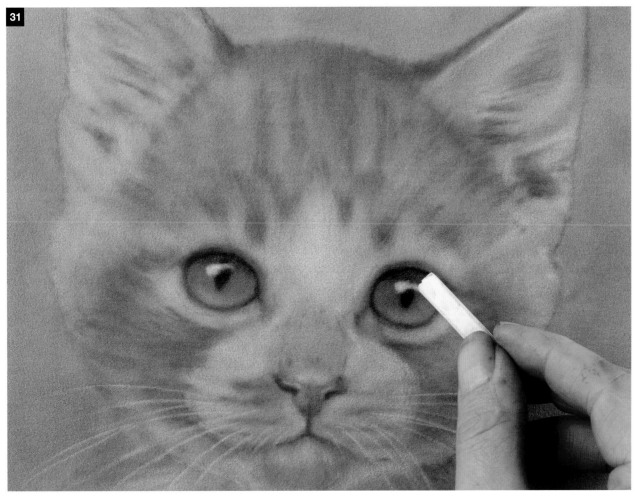

Afterword

I hope you have enjoyed reading and using this book as much as I have enjoyed writing it. I hope also that you have found inspiration from the various artworks within, and learned some new techniques and styles for drawing, painting and illustrating cats, one of my favourite subjects.

Many of us are fortunate enough to have had cats who have grown from kittens to old age, or have rescued older cats. To me and my partner, Liz, the seniors have always had a special place in our hearts, so it would not seem right to end this book without giving the 'oldies' a special mention.

In the main, older cats tend to sleep for most of the day, even more so than the younger ones; so it would be probably more appropriate to draw and paint them in relaxed poses, on a comfortable bed or lap close to a warm fire, or perhaps dozing in a sunny spot in the garden.

As the 'oldies' may not be as playful as they were as kittens, they will naturally lose some muscle tone, and bony areas such as the spine and hips will be more prominent. Like me, they are also likely to have become a little greyer around the muzzle. Pay particular attention to older cats' eyes: the older they get, the more speckled their irises. You may also see some cloudiness over the pupils.

However, as well as character, there is still beauty in old age. In the painting opposite, I have tried to capture the sweet nature and beauty of our first cat, Nina, enjoying her own favourite garden spot. Nina was with us when I began writing this book; sadly passing on before I completed it.

Nina's Garden
Older cats love a secluded spot in the garden, watching birds or just sleeping. Soft dappled light was created using pastels on velour for a nostalgic painting of our first cat, Nina.

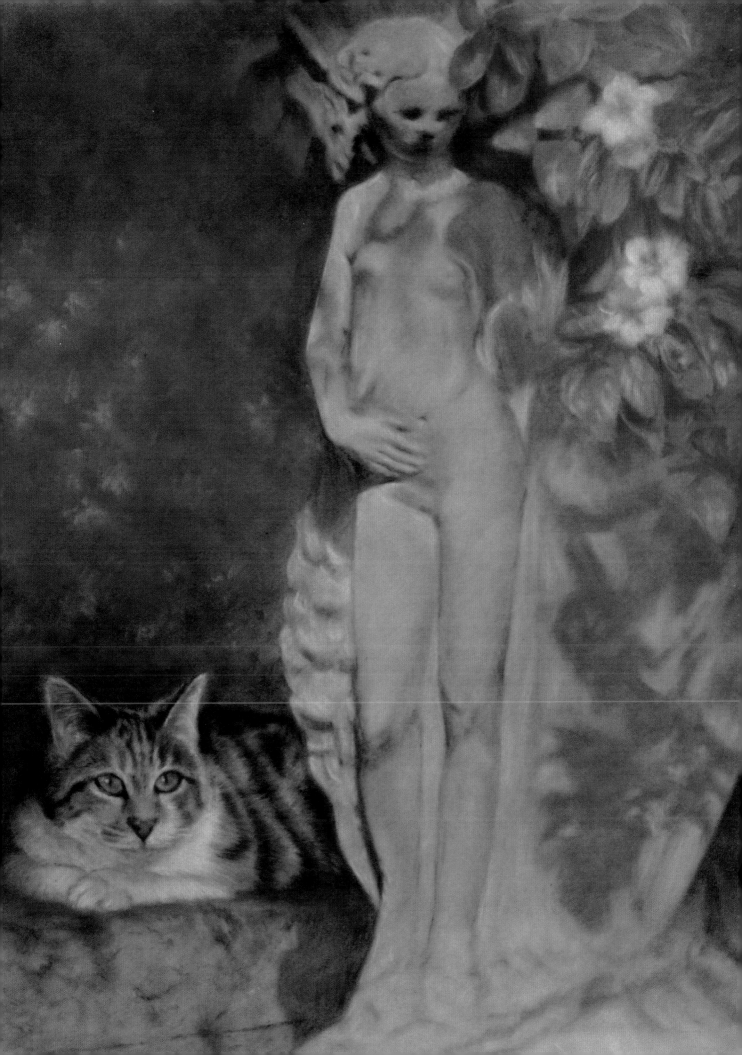

Studio Mischief

Throughout the ages, cats have enjoyed a comfortable, bohemian existence in artists' studios, where they can find a seemingly endless supply of 'toys' with which to play. I am sure, as in my case, many of these artists found welcome distractions from the intensity of the creative process in their cats. This image of my own studio and cats is rendered in ink pen and watercolour.

Index